PAINTING WITH PASTELS

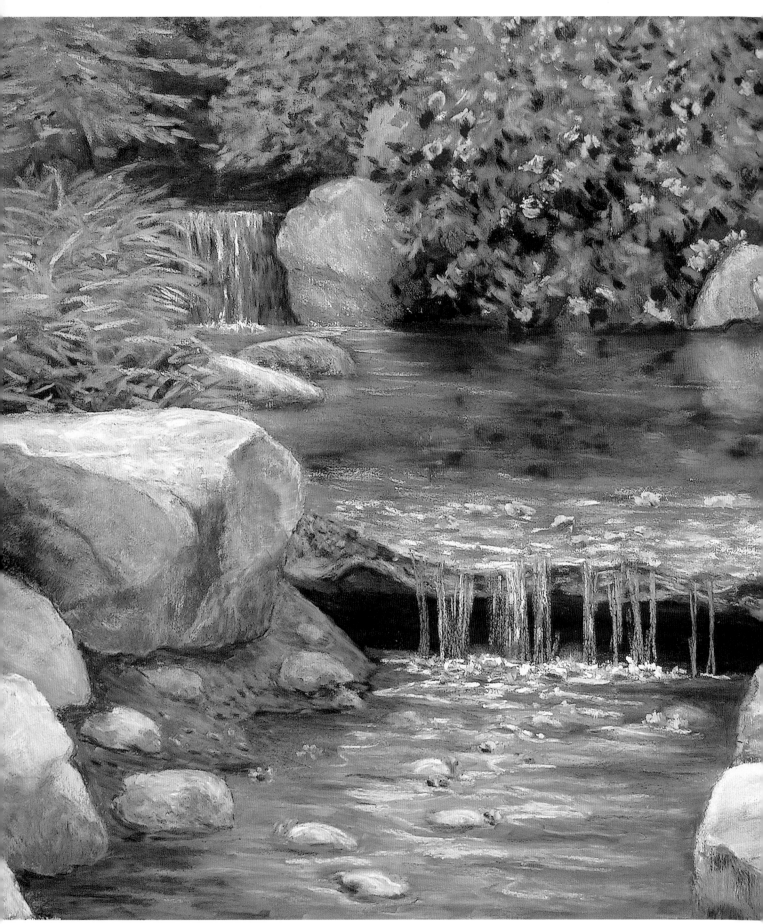

Petals in the Stream
11" × 14" (28cm × 36cm)

painting with
pastels
Easy Techniques to Master the Medium

Maggie Price

Founding Editor of The Pastel Journal

NORTH LIGHT BOOKS
CINCINNATI, OHIO
www.artistsnetwork.com

about the author

Maggie Price is the co-founder, former editor and current contributor of *The Pastel Journal*; she has written numerous articles for it and other magazines. She studied fine arts at the University of Missouri and has attended many workshops with well-known artists, such as Albert Handell, Elizabeth Mowry, Eric Michaels and Deborah Christensen Secor. She currently conducts her own workshops on pastel painting in the United States and other countries and is an active member in numerous art societies. Her work can be seen at www.maggiepriceart.com.

Painting with Pastels. Copyright © 2007 by Maggie Price. Manufactured in China. All rights reserved. No part of this book may be reproduced in any form or by any electronic or mechanical means including information storage and retrieval systems without permission in writing from the publisher, except by a reviewer who may quote brief passages in a review. Published by North Light Books, an imprint of F+W Publications, Inc., 4700 East Galbraith Road, Cincinnati, Ohio, 45236. (800) 289-0963. First Edition.

Other fine North Light Books are available from your local bookstore, art supply store or direct from the publisher.

11 10 09 08 5 4 3 2

DISTRIBUTED IN CANADA BY FRASER DIRECT
100 Armstrong Avenue
Georgetown, ON, Canada L7G 5S4
Tel: (905) 877-4411

DISTRIBUTED IN THE U.K. AND EUROPE BY DAVID & CHARLES
Brunel House, Newton Abbot, Devon, TQ12 4PU, England
Tel: (+44) 1626 323200, Fax: (+44) 1626 323319
Email: postmaster@davidandcharles.co.uk

DISTRIBUTED IN AUSTRALIA BY CAPRICORN LINK
P.O. Box 704, S. Windsor NSW, 2756 Australia
Tel: (02) 4577-3555

Library of Congress Cataloging in Publication Data
Price, Maggie
 Painting with pastels : easy techniques to master the medium / Maggie Price. – 1st ed.
 p. cm.
 Includes index.
 ISBN-13: 978-1-58180-819-3 (pbk. : alk. paper)
 ISBN-10: 1-58180-819-4 (pbk. : alk. paper)
 1. Pastel drawing–Technique. I. Title.
NC880.P75 2007
741.2'35–dc22
 2006029048

Edited by Erin Nevius and Jason Feldmann
Designed by Guy Kelly
Production art by Kathy Bergstrom
Production coordinated by Matt Wagner

F+W PUBLICATIONS, INC.

Contributing Artists

Deborah Bays

Greg Biolchini

Thomas DeCleene

Sam Goodsell

Bill Hosner

Richard McKinley

Desmond O'Hagan

Deborah Christensen Secor

Ruth Summer

metric conversion chart

To convert	to	multiply by
Inches	Centimeters	2.54
Centimeters	Inches	0.4
Kilograms	Pounds	2.2
Ounces	Grams	28.3
Grams	Ounces	0.035

acknowledgments

No artist exists in a vacuum. I have learned from every painting I've ever studied in a gallery or museum, from every instructor, and from every artist I've interviewed or read about. I am grateful to all those artists for the opportunity to learn and committed to my mission to pass that knowledge on to others.

Many thanks to the artists who contributed to this book and generously shared their expertise. It is an honor to have their paintings and demonstrations included, and I am very grateful to each of them.

Special thanks to North Light Editorial Director Jamie Markle, who not only guided me through the first phases of the book outline but made substantial suggestions for improvement. And to Erin Nevius and Jason Feldmann, my editors, for their support and great ideas. It has been a delight to work with all of these fine editors.

I also want to thank the readers of *The Pastel Journal* magazine, whose response to my articles over the years made me believe I could write this book, and all those who have taken my workshops, who helped me learn to teach.

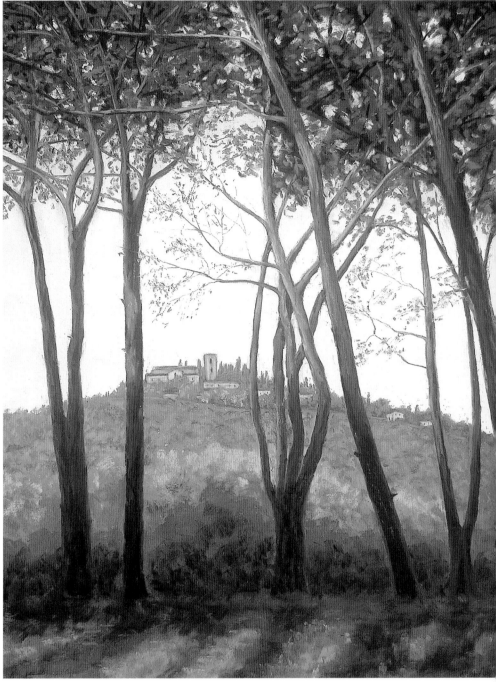

Montecatini Alto
11" × 14" (28cm × 36cm)

dedication

Dedicated to my husband, Bill Canright, with thanks for his support and encouragement, as well as his photographic and artistic expertise.

table of contents

CHAPTER FIVE

painting from life
Page 97

WHEN IS YOUR PAINTING FINISHED?
Page 122

CONTRIBUTORS
Page 124

INDEX
Page 126

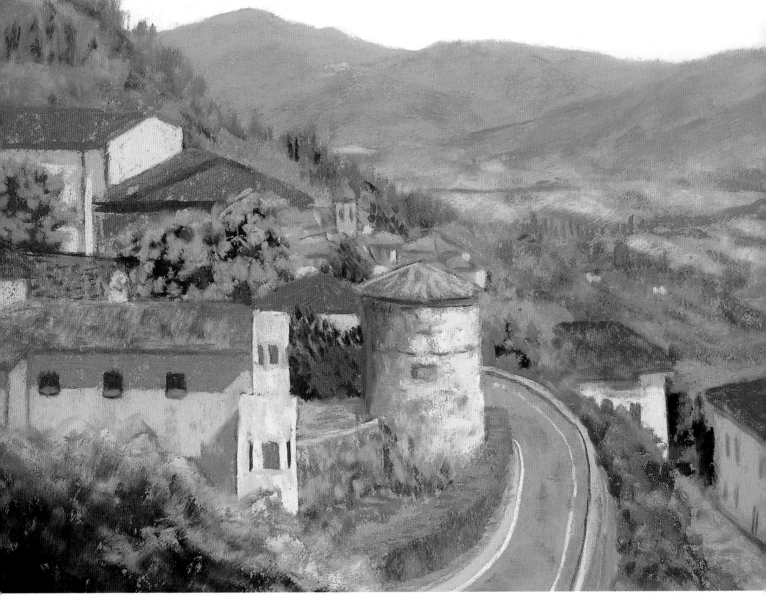

View from Piazza Garibaldi
8" × 11" (20cm × 28cm)

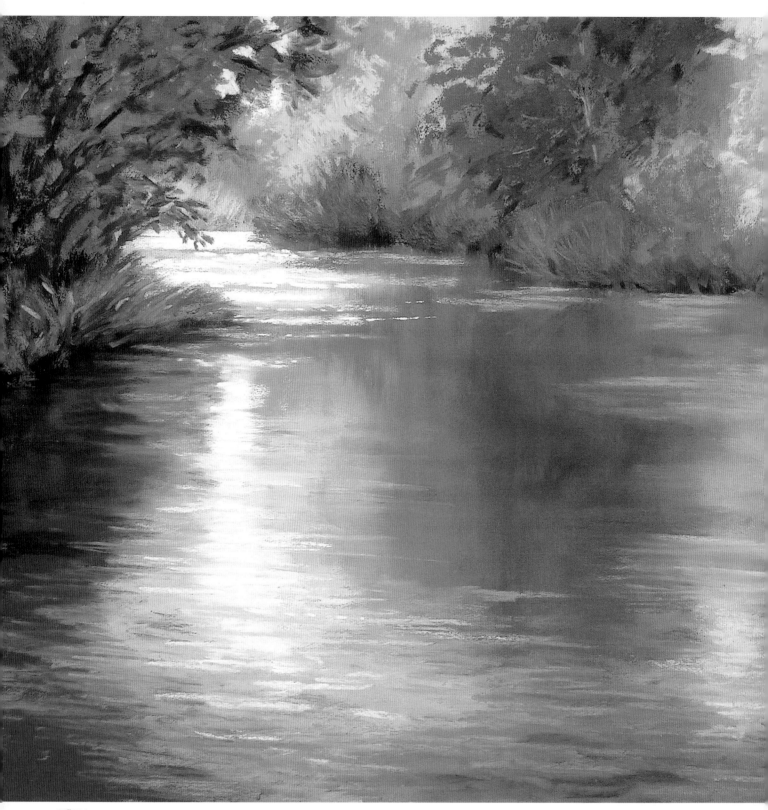

Still Waters
11" × 17" (28cm × 43cm)

introduction

Painting with pastel is the most direct way of applying color to a surface. Pastels are made of the same pigments as oil paint and watercolors, but the pure color is only mixed with enough binder to hold it in stick form. Rather than brushing on a liquid mixture and waiting for it to dry, and possibly change colors, the artist working with pastel applies the dry pigment directly to the surface.

It is this immediacy of application that makes the medium so enticing. Open a box of pastels, and the brilliant array of colors tempts you to pick up a stick and make a mark. Once begun, the visual rewards are so great that it's almost impossible to stop.

Like many artists, I moved from my childhood love of drawing and coloring with crayons to painting with oils. It was many years later that I discovered pastels. It seemed to me that paintings in pastel had an unusual luminosity and brilliance, a special quality of color I'd never been able to achieve in oils. I bought a set of pastels and began learning how to use them, and I've never let them go.

What I loved then and still love about pastels is that you can use them to draw as you would with a crayon or pencil, and you can stroke with the side of the pastel as you would with a brush. The color of the pastel is the color it will be on the paper—but layering, blending, glazing and many other techniques we're about to explore offer a world of possibilities in the use of the color.

People often ask why I say I paint with pastels rather than draw with them. You can certainly draw with them, and painters as far back as Leonardo da Vinci (1452–1519) have done so, using one or more sticks of pastel and drawing as one would with a pencil. Drawing is a matter of line, however, while painting deals more with shapes, masses and color. When you use pastels in this way and cover the surface with pigment, the result is a painting.

Pastel is a forgiving medium: If you change your mind, it's easy to rework. The techniques necessary to begin producing pleasing paintings are easy to learn, and yet the possibilities of the medium are endless and can provide challenges for years to come. The demonstrations and explanations in this book will get you well on your way to painting in pastels.

Versatility, immediacy, luminosity, brilliance, ease of use—all these are attributes of working in pastel, but probably the most important of all is that it's just a lot of fun!

Inspirational Gallery

To inspire you and show you what is possible with this delightful medium, I've included this inspirational gallery. These paintings demonstrate some of the many different styles that can be achieved with pastels, as you'll see in the works of Greg Biolchini, Richard McKinley, Deborah Christensen Secor, Sam Goodsell, Desmond O'Hagan and Deborah Bays. After looking at these beautiful paintings, I know you'll be eager to turn the page and start learning how to use the medium yourself.

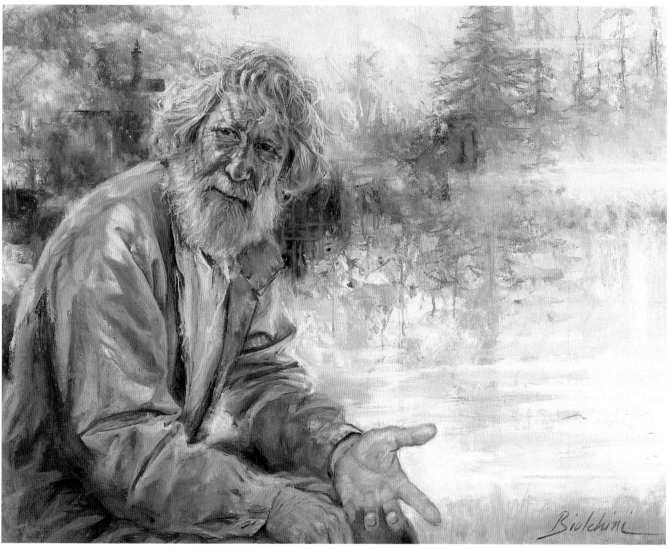

Man From Mt. Vision
24" × 18" (61cm × 46cm) by Greg Biolchini

Merging Pastels and a Wet Medium
GREG BIOLCHINI

I painted this portrait to near completion in about four hours as a demonstration in a crowded booth for the Mount Vision Pastel Company. The painting was done on a pumice ground I prepared myself on a two-ply rag mat board, as described on page 26. First, I quickly drew in the big shapes directly onto the white pumice board with Mount Vision Soft Pastels. I then brushed a generous amount of water onto the pastel, turning the dry pastel into a drippy wet wash. When it dried, I worked back over the loose wash, adding more dry pastel and water, merging the wet and dry pastels together as I redrew and refined the portrait. A convincing likeness emerged from accurate drawing and re-drawing as this portrait progressed. The reference for this painting was a photograph I took of this gentleman.

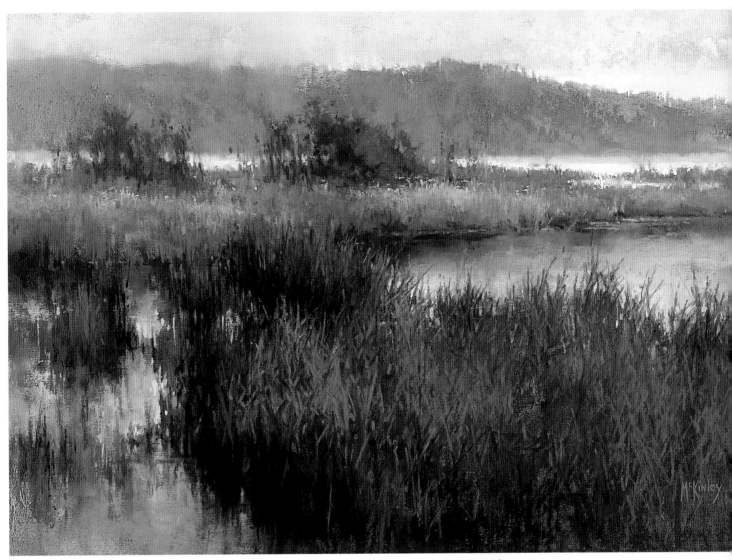

Waters Edge
12" × 17" (30cm × 43cm) by Richard McKinley

Utilizing an Oil Stain Underpainting

RICHARD MCKINLEY

Waters Edge was painted in the studio, working from sketches and a small oil painting done en plein air, which is my preferred method of studio painting. (See "Using Color Studies as a Reference," page 118.)

To clarify the concept, I started by making a few thumbnail sketches, and then drew the composition on a piece of mounted museum grade Wallis paper with a 2b pencil. Next, I applied an oil stain underpainting (see page 71). The underpainting created a translucent wash of color that guided the choices of pastel to be applied. The first strokes of pastel were applied in the main area of interest. The darkest and lightest masses were indicated, so that a general value relationship would exist before any surrounding area was completed. I initially worked with thin applications of pastel so more pigment could be added as the painting progressed.

Midway through the painting I allowed a lot of the underpainting to show through the foreground grasses, hoping this would be enough to create the essence of what was there without distracting from the main area of interest. After evaluation it became clear that due to the strong use of color, and contrast in the area of interest, more definition would be required in the foreground to anchor it and allow for the proper depth. The final half of the painting was the gradual resolving of the foreground and a few minor intensifications of color or value in surrounding areas.

Blazing Complements
11" × 17" (28cm × 43cm) by Deborah Christensen Secor

Using a High Contrast in Values and Complementary Colors
DEBORAH CHRISTENSEN SECOR

The key to the success of *Blazing Complements* is the high contrast in values, as well as the complementary orange and blue theme.

To begin the painting, I chose a medium green-gray tone to apply over the entire surface of the white Wallis paper. I covered the paper with a loose layer of pastel using the flat side of the stick, and then used a foam house-painting brush to vigorously scrub the pigment into the grain of the paper. Finally, I used the brush to thoroughly brush away any excess dust.

This medium value and functionally neutral color works to enhance both warm and cool colors, supplying a slightly cool cast beneath the blazing orange on the sunlit side of the adobe buildings and, in contrast, harmonizing the blue shadows on the pavement with a faintly warmer color underneath. This unifies the entire color scheme of the painting. When I'm able to find a color such as this green-gray that functions as a bridge color, working in contrast to both the warm and cool colors in my painting, I prefer to tone the entire piece of paper, rather than doing a complementary underpainting, such as that shown on page 52. The solid tone allows me to do a fairly detailed drawing in extra soft thin vine charcoal, similar to that shown on page 54. The drawing gives me a chance to sort out where the major compositional elements lie, in order to maintain a careful balance of the light and dark masses.

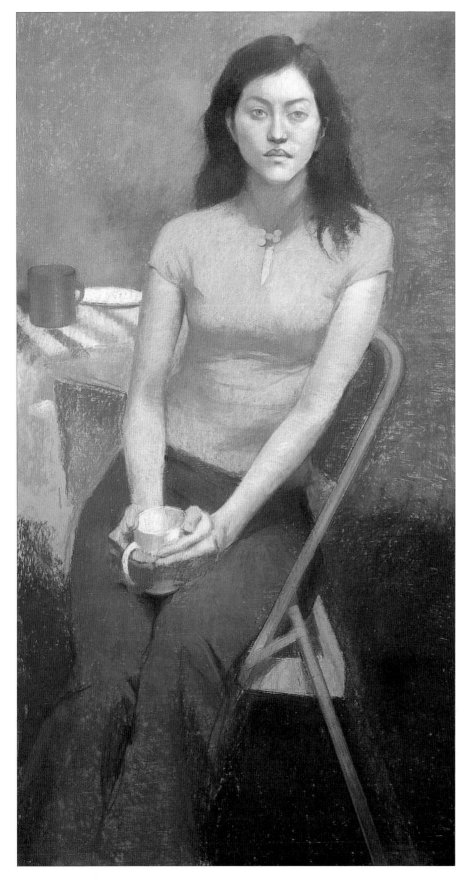

From Charcoal Sketch to Color Layering

SAM GOODSELL

I liked the way the model leaned in this composition. It was important to get the gesture right in the early stages of the drawing. Sketching with soft vine charcoal, my first sketch had her too straight up and down, so I rubbed out the sketch and did it again. As in the demonstration beginning on page 100, I then used the charcoal to block in the large masses of dark, and pulled out light shapes with a chamois. In this early stage it's a very angular drawing, showing the planes, and an approximation of light and shadow shapes without any details.

Once that's complete, I begin blocking in with the base colors or dominant colors right over the charcoal, paying attention to the values I've already established. The base color in the shirt, for example, is a blue. As the painting develops, I layer over more subtle distinctions of color, such as blue-violet, blue-gray, and even umbers. Painting in natural north light gives everything a little bit of a blue-gray cast, but basically I respond to the colors I see and paint them.

From the very beginning of the drawing and throughout the painting, I squint to eliminate insignificant details and see basic shapes, light and shadow. That keeps me from putting in detail that is not necessary for the painting, allowing me to emphasize what is important and let go of what is not important.

Waiting
54" × 28 ½" (137cm × 72cm) by Sam Goodsell

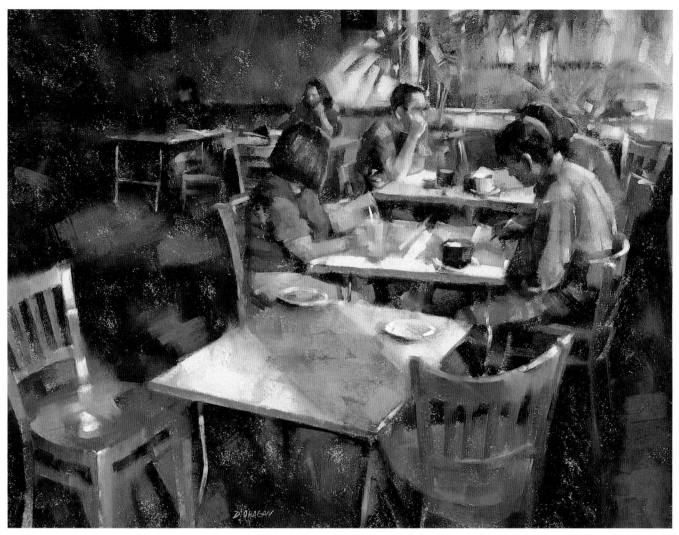

Late Morning, St. Mark's Coffee House
11" × 17" (28cm × 43cm) by Desmond O'Hagan

Varying the Direction and Pressure of Pastel Strokes
DESMOND O'HAGAN

While painting *Late Morning, St. Mark's Coffee House*, it was crucial to identify the important shapes within the composition. The shapes that reflect the sunlight streaming through the open windows are where I want the viewer's eyes to go first. I first composed the painting by drawing the large, darker shape in an abstract pattern. This was the first step in establishing the contrast in lights and darks that would make the sunlit areas stand out in the end. Using the sides of the pastel, much like the width of a large brush, I create the dark shapes by varying the direction of the stroke as well as the pressure on the pastel (see page 23 for another example). This technique gives the shapes character and visual texture and avoids creating a monotonous pattern. Varying the pressure on the pastel can create a nice visual texture as opposed to applying several layers of physical texture that run the risk of becoming muddy. Keeping those early shapes dark and subdued helped give the lighter, brighter colors more strength later. After painting in the middle values, I concentrated on the sunlit areas. I used combinations of orange, yellow, pink, and light blue to create the feeling of a warm, sunlit room. Using the edge of the pastel to imply some detail at the end of the painting helped define certain shapes. The final effect of light was achieved in balancing these different techniques.

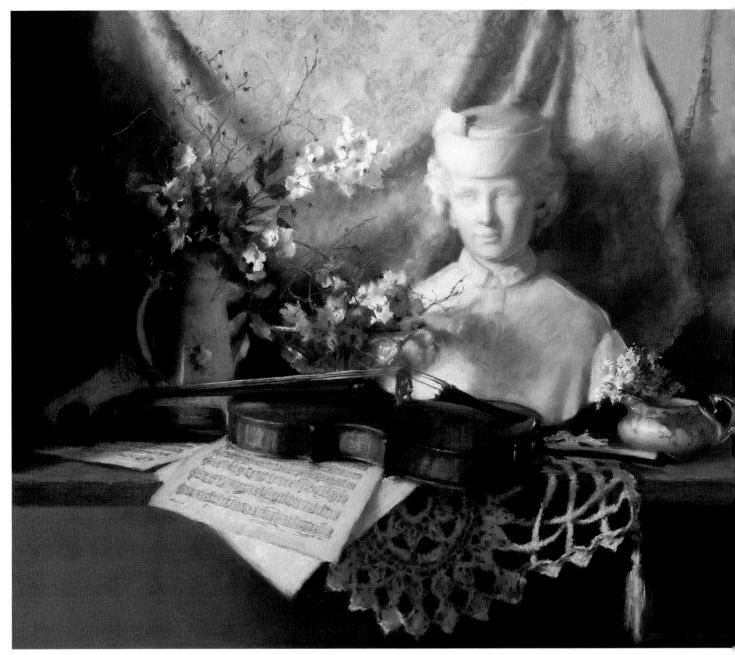

Pianissimo
24" × 30" (61cm × 76cm) by Deborah Bays

Moving the Viewer's Eye with Value and Edges
DEBORAH BAYS

I often think of making a painting as I would think about playing an instrument. Where I normally play—or in this case paint—scales, arpeggios and études, it was my intent to play a concerto with *Pianissimo*. I wanted to use all of the technique that I could muster at the time to create a larger and more complex piece. This was a challenge that I set for myself. I thought I knew where I was going (always a dangerous assumption) and used the steps described in the demonstration of *Milk Pitcher with Pears and an Apple*. (See page 104.)

There were plenty of challenges to deal with. I wanted to move the viewer's eye through the painting using value and edges. I selected the marble bust for its inherent advantages as the focal paint. It is light in value, takes the light beautifully and has the added plus of the "face factor;" which is that a face, human or animal, will always draw the focus. I also wanted to develop different texture utilizing some of the unique attributes of pastel. I allowed color to take a backseat to the other elements, staying with a tight, warm palette. I had to remind myself often to paint the light falling on the objects and not the objects themselves.

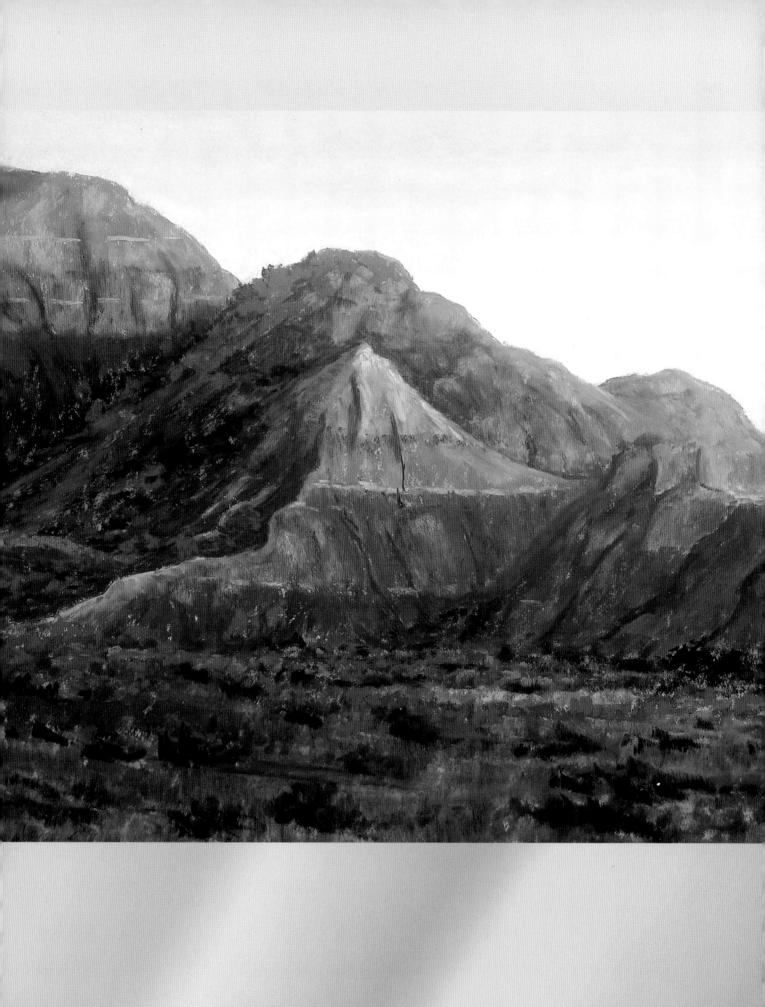

what you'll need to begin

Like many artists, I began my artistic career with oil paints. After many years and a developing problem with sensitivity to solvents, I switched to acrylics. Some years later, I began to feel my work was getting stale. I dabbled in watercolor, but then I discovered pastels. From across the room, the glow of the colors in pastels caught my eye again and again, so I decided to give them a try. I fell in love with the colors, the texture and the ability to achieve effects I'd never come close to in any other medium. I loved the immediacy—the fact that what you see on the surface is what you get, with no waiting to dry, no color changes, no varnish—and the direct, tactile application of the medium. I've come to believe it's the most versatile, and in many ways the easiest, of all the mediums. But like any medium, pastel has a few tricks of the trade, and I'm happy to share them in these pages.

Evening in Palo Duro Canyon
11" × 17" (28cm × 43cm)

types of pastels

There are three main types of pastels: soft pastels, oil pastels and pastel pencils. As you become more experienced with each, you can decide which to use to create the look you want for each painting.

Soft Pastels

Soft pastels are labeled as such to distinguish them from oil pastels, but not all soft pastels are equally soft. Soft pastels can range from hard sticks that do not break or crumble easily and require firm pressure to make a mark on the surface, to very soft sticks that leave color on the surface with the lightest touch. When people refer to "hard pastels," they mean harder sticks of soft pastels—usually brands like NuPastels or Faber-Castell Polychromos. Soft pastels could also be called dry pastels—they are pure pigment mixed with enough binder and water to be formed into sticks, and then dried until the water has evaporated.

Pastel Pencils

Falling into the "hard" range of soft pastels, pastel pencils can be sharpened to a good point.

There are several brands of pastel pencils, including Carb-Othello, Pitt, Derwent, and Conté. Experiment to see which brands you like best, as textures vary and their color ranges are different.

Pastel pencils are useful when you need to make a fine line; for example, tree branches across an already-painted sky, or fine hairs around the face in a portrait.

harder pastels vs. softer pastels
A stroke made with a harder pastel can create a firm line, and may need more pressure to apply the pigment to the paper. The strokes made with softer pastels cover easily but can quickly fill up the tooth or grain of the surface. (See Chapter Three for more information about strokes.)

They are also useful in areas where you need to soften a hard edge. Holding the sharpened pencil close to the end away from the point, loosely stroke back and forth an edge to blur it slightly and add color at the same time. If, for example, you need to soften a sharp dark edge in the background of a painting, you can use a blue pencil of the same or slightly lighter value to gently break up and round the edge. In painting water, a blue pencil can be stroked lightly across the water and reflection area, blending and softening the image.

Oil Pastels

Oil pastels are made by mixing pigment, a small amount of mineral or vegetable oil, and a wax binder. They have a waxy feeling not unlike crayons. Oil and soft pastels cannot be intermixed, and techniques that work with one may not work with the other. This book does not deal with oil pastels.

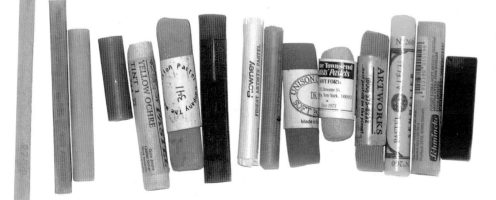

types of pastels
From harder pastels to the very soft, a wide variety of firmnesses and textures are available. While this illustration does not feature all the pastels available, it shows a variety from harder to softer. Left to right, the brands are: Nupastel, Faber-Castell Polychromos, Yarka, Rembrandt, Winsor & Newton, Mount Vision, Art Spectrum, Daler-Rowney, Pastels Girault, Unison Colour, Townsend, ArtWorks, Sennelier, Schmincke and Ludwig pastels.

a starting assortment

You may have seen artists' studios with tables or cabinets full of hundreds of pastels. However, you don't have to make a huge investment to get started. You can buy a set or two, or if you have an art retailer nearby where you can purchase individual sticks, you can custom-select your own set to get started. Later, as you become more proficient with the medium and familiar with the different brands, you can add more of your favorites to your collection.

As you experiment with various surfaces and pastels, you'll probably choose softer pastels for working on toothier surfaces and firmer sticks if you prefer smoother surfaces. Most artists use an assortment of textures, beginning with harder pastels on the first layer and using softer ones on subsequent layers.

start smart
A beginning assortment of fifty to one hundred pastels of various brands and hardness/softness won't break the bank but will still give you a sufficient range to begin creating pastel paintings.

A Basic Setup for Pastels

You don't need a separate studio or a lot of equipment to get started using pastels. A table to hold a backing board and your basic assortment of pastels will get you started. If you like to work at an easel and have one available, set it up next to a table where you can lay out the pastels you want to use.

Taping your paper to a board keeps it steady while you're working. A piece of Masonite a little bigger than your painting surface makes a good backing board, but if you don't have one there are other possibilities. Two pieces of foamboard taped together will be sturdy enough. If you've previously worked in watercolor and have a lightweight watercolor board, that's an excellent backing board. If you don't have any of those, you can tape two or three pieces of stiff cardboard (like a cut-up cardboard box) together; just make sure no fold or crease lines will be behind the paper you're going to work on, as they may cause unwanted lines to appear in your painting.

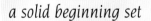

a solid beginning set

Five to ten sticks of each of the following colors, in a range from light to dark in assorted brands:

- Primary colors: red, yellow and blue
- Secondary colors: orange, green and purple
- Tertiary colors: red-orange, yellow-orange, yellow-green, blue green, blue-violet and red-violet
- Earth colors: browns and reddish-browns
- One stick each of black and white, and a few grays

Additional items you may want to experiment with:

- Blending tools, such as tortillions (stumps) or soft, rubber-tipped paint shapers (I use the Colour Shaper brand)
- Spray fixative
- Odorless turpentine for underpainting
- An old brush or an inexpensive synthetic brush for brushing in turpentine
- Kneaded eraser
- Extra-soft vine charcoal for drawing
- Pastel pencils (useful for drawing fine lines and signing your paintings)

an economic easel
Here's an inexpensive way to start: Tape your paper to a backing board and prop it up on a tabletop, leaning the board against a stack of books. While it may not be as steady or firm as a tabletop easel or drawing board, it works. A towel underneath keeps things from slipping and catches dust.

setting up your work space

One of the first decisions you will need to make is whether you would like to work at an upright easel or on a flat piece of paper. There are advantages to both.

Working Vertical

Some people prefer to work with the paper or other surface flat on a table. While this is fine, pastels tend to create dust as they're applied, and that dust will accumulate on the surface of the paper. Blowing it off puts the pigment dust in the air. A better solution is to work with the surface held vertically, whether you stand at an upright easel or sit in front of a table easel. The dust created by the strokes of pastel will naturally fall off the paper, keeping unworked areas cleaner. You can fold a piece of paper to create a well on the easel shelf and catch the dust as it falls.

Working Flat

If you use a drawing board the surface can be slanted or left flat, though a flat surface will require that you pick up the paper now and then to knock off the dust. If you don't have a drawing board or table easel, you can prop your board up against anything that will hold it at the proper angle.

Set Up Your Work Space

A big, beautiful studio is the dream of many artists, but most start with something far less grand. A corner of a table or a small nook out of the way of traffic is often all the "studio" a successful artist may have.

As artists continue to work in pastel, they often purchase more and more sticks, choosing certain brands for color or texture. The result may be hundreds of pastels—which require a place to store and organize them—but you don't need that to begin.

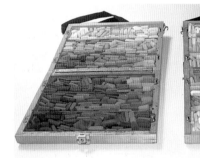

storing your medium
Many artists organize their pastels into a box, sorted by value (lightness or darkness) or by color. The same box can be used in the studio or in the field.

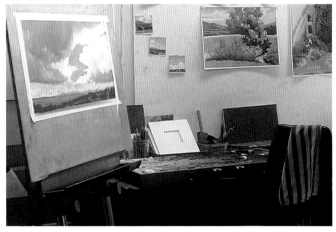

nothing fancy
Simplicity is the key! Artist Deborah Christensen Secor works in a small space in her home, leaving her easel and pastels set up so she can start and stop as needed.

using an easel
All you need to work at an easel is room to set it up and a space on which to lay out your pastels. If you can leave the setup in place, it will make it easy to stop when you need to and return to your painting as you can. Unlike wet mediums, pastels won't dry out and you can simply pick up where you left off.

keep it clean

The first time you pick up a stick of pastel, you'll notice that some of the color comes off on your fingers. If you use a barrier cream or liquid, it will make it easier to get all the color off your skin when you wash your hands after a painting session. There are a variety of brands available; check your art supply retailer and experiment to see which you like best. Working the cream or liquid into the skin well, and especially under the fingernails, makes cleanup easier.

Many artists wear a mask while working so that they don't inadvertently breathe the pastel dust. People with allergies are sensitive to all sorts of dust, and they may also use an air filter or exhaust fan in the studio to keep the pastel dust out of the air. Wiping up dust with a damp paper towel captures it, while vacuuming redistributes the dust into the air.

Keep Your Pastels Clean to See the Colors

As you work with pastels, your fingers or gloves will pick up color that can be transferred to the next stick you pick up. Without some method of cleaning the sticks, they'll eventually all become shades of gray! You can wipe the sticks with a paper towel as you finish, or you may choose to store your working palette (the assortment you're using on a particular painting) in a substance such as coarse cornmeal or rice that helps keep them clean. If you use a pastel box made with foam liners for storage of your pastels, they will become cleaner each time you close the box.

use that dust!

Collect your pastel dust in a folded paper or from your easel tray and store it in a small jar until you have about a quarter of a cup. You can also add tiny broken pieces from pastels that have been dropped or chipped. Grind up any chunks or pieces (either using a mortar and pestle like you'd use in the kitchen for grinding spices, or by placing them on a hard surface on paper and pounding with a hammer to reduce the chunks to dust). Pile the dust on a piece of wax paper and slowly drip water onto it, stirring with a disposable plastic spoon or your gloved finger until it becomes pasty, about the consistency of firm cookie dough.

With a gloved hand, roll the paste into a stick. Let it dry for a day or two, until it's completely dry and no longer cool to the touch. The combination of the many colors of dust will result in a lovely neutral gray pastel, and you'll have the satisfaction of knowing you've used all the dust that would have been thrown away.

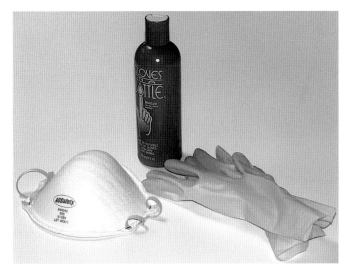

easy cleanup
Masks, gloves and barrier creams or liquids are all things pastel artists may use to keep their hands clean and avoid inhaling dust.

keeping pastels clean
Some people store the pastels they're using for a painting-in-progress in coarse cornmeal or rice. Shaking the box causes the cornmeal or rice to rub against the pastel sticks and remove loose surface dust. For longer-term storage, using a box with foam liners helps keep them clean and prevents the sticks from rubbing against each other.

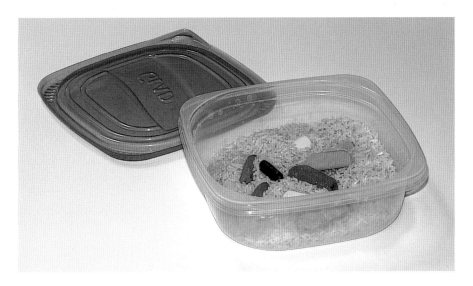

different types of paper surfaces

Paper surfaces range from smooth to rough and can be chosen not only for personal preference but for subject. For example, if your subject requires hard edges and straight lines, choose a smoother surface such as Canson or Rives BFK, or an evenly-sanded paper such as Art Spectrum or Wallis Sanded Pastel Paper. But if you want a textural, rougher surface for a subject that does not need hard, defined edges, you might prefer a surface such as Sennelier La Carte, Schmincke Sansfix or even watercolor paper.

Commercially Available Surfaces

You can find many surfaces for pastel at your local art retail store. Many will be specifically labeled as pastel papers, but others, such as printmaking paper or watercolor paper, may not mention pastel even though they will certainly work for the medium. Experiment with various surfaces to determine what you like best, and which suits your subject and working style.

texture terminology

Tooth or *grain* refers to the texture of the paper. The more tooth a paper has, the more layers of pastel can be applied.

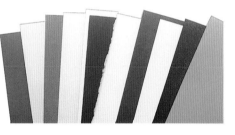

papers of many textures
There are lots and lots of different kinds of paper to choose from, depending on what you like and even the subject of each work.

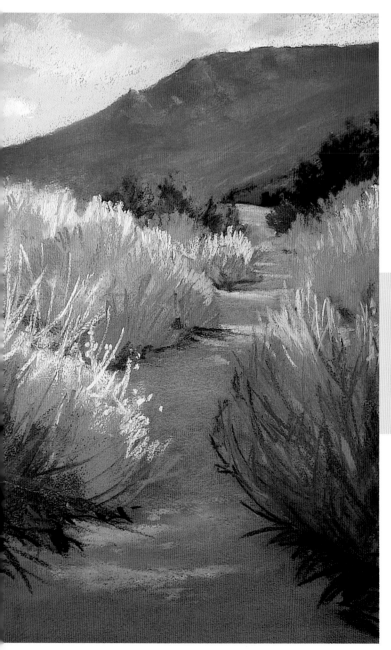

detail
Detail shows the grain of the paper as a stroke is applied.

using rough paper for texture
This painting by Deborah Christensen Secor is on Schmincke Sansfix paper, a rougher surface. Secor likes the texture of the paper because it holds the pastel in place well, yet allows the pigment to be lightly blended.

Cool Morning Walk
11" × 17" (28cm × 43cm) by Deborah Christensen Secor

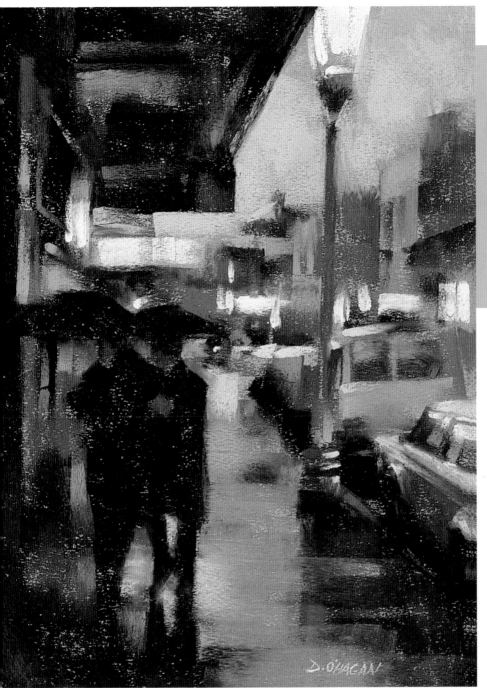

detail
A close-up view of O'Hagan's painting illustrates how he's allowed the paper to show through the pastel stroke.

using smooth paper for texture
Desmond O'Hagan works on Canson paper, a smoother surface, using broad strokes to cover the surface without multiple layers. He varies the pressure of the stroke to create a visual texture rather than a physical texture.

Chinatown, San Francisco
9" x 12" (23cm x 30cm) by Desmond O'Hagan

different surfaces, same pastels

On these pages, the same assortment of pastels was used to paint a sketch of a pear on different surfaces. Note the difference in appearance of texture and coverage between surfaces.

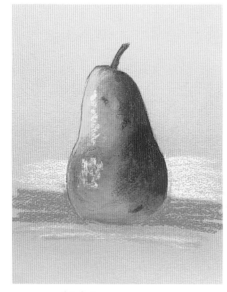

canson mi-teintes paper
Canson paper, available in a range of colors, has long been a popular surface, especially for figure drawing and portraits. It has both a smooth side and a rough side, and artists generally have a strong preference for one or the other; the rougher side can take more layers of pastel, but you may find it difficult to completely cover the pattern of the paper. Many artists who prefer the smooth side use fixative as they work to allow them to add more layers of pastel.

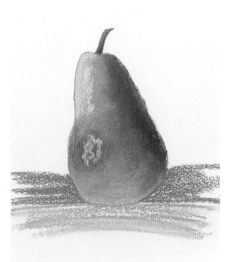

rives bfk printmaking paper
This paper has a smooth surface that can take a surprising number of layers of pastel, though extremely soft pastels may fill the limited tooth rather quickly. It's available in many colors and is a tough surface that can handle erasures.

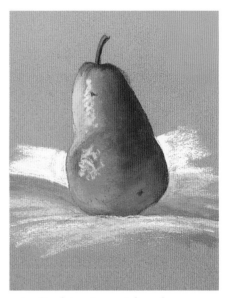

sennelier la carte pastel card
Often referred to simply as "pastel card," this surface comes in a range of colors. Its somewhat toothy surface is made of a vegetable fiber affixed to a firm support, and allows for numerous layers of pastel. It's important to note that a spot of water will cause the fiber surface to come off, so it's not a good choice for working outdoors if rain is in the forecast!

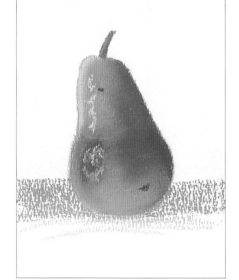

aquarelle watercolor paper
Used simply as purchased from the art supply store, with no other prepping, watercolor paper has a limited tooth and can be quite textural. Some artists give it a light sanding with a fine-grit sandpaper to rough up the finish. One advantage of the surface is its toughness; another is that it can be pH neutral. (See page 31 for more information on pH factors and archival qualities of materials.)

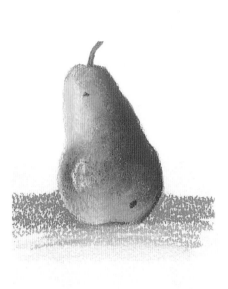

multimedia artboard
Available in black or white, this surface has a texture similar to watercolor paper on its rougher side. It can be underpainted with either oil or water-based media. It's acid-free and pH neutral.

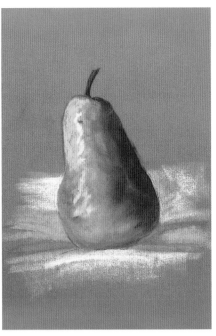

velour paper
Available in several colors, this soft, velvety surface takes softer pastels well, but in limited layers.

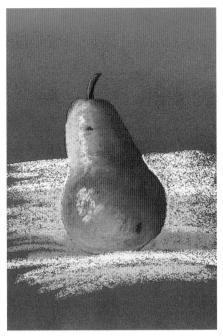

schmincke sansfix
This paper has texture similar to sanded paper and comes in a range of colors. It allows generous layering and can take a sharp line.

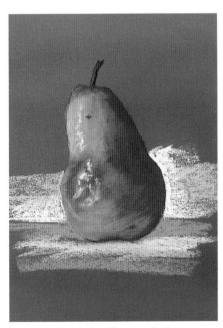

art spectrum colourfix sanded paper
This company also sells pigment in jars for application to your own surface. The prepared sheets come in a range of colors and will accept wet media underpaintings, as well as quite a few layers of pastel.

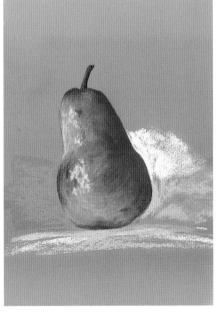

ampersand pastelbord
A thin sheet of material similar to Masonite is the backing for this textured board, available in a number of colors. Pastels seem particularly brilliant applied to this surface, which allows layering and wet media underpaintings.

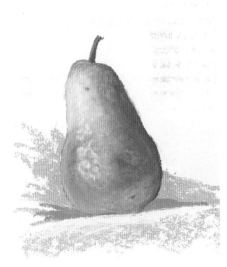

wallis sanded pastel paper
This smooth-textured, sanded surface has an even grain and will accept many, many layers of pastel. The pastel can even be washed off and the paper re-used. It can be underpainted with wet media, from oil washes to watercolor, or pastel applied and washed with various liquids. (See "Beginning with an Underpainting," page 52.) Because its base is watercolor paper, it is archival and pH neutral. It's available in white and a neutral beige called Belgian Mist.

control texture with a homemade surface

New surfaces come onto the market frequently; try them as they become available. After experimenting with surfaces available through art supply stores, you may want to try making your own if none work well for you purposes. One of the big advantages of preparing a surface yourself is that you can control the amount of tooth by adding more or less pumice powder to the mix.

materials list

Gesso

Foam brush (available at hardware and hobby stores, as well as art supply stores)

Liquid acrylic paint or tube paint

Pumice powder (available from art supply retailers)

Museum, illustration or mat board

Masking tape

Measuring and stirring spoons

Mask (pumice powder should not be inhaled)

Gloves

Container (plastic is best) with a tight-fitting lid

recipe for pumice mix

Start with these proportions and then modify the mixture to make a rougher or smoother grit surface (by adding more or less pumice) as you desire. Quantities given are estimates, as each artist will have a personal preference depending on the type of surface desired.

- 1 cup gesso
- 3–4 teaspoons liquid acrylic paint or tube paint to create appropriate color (if you use tube paint, you may need to add a little water to thin the mixture so it can be brushed onto the surface)
- 3–6 teaspoons pumice powder, more as needed to achieve desired texture

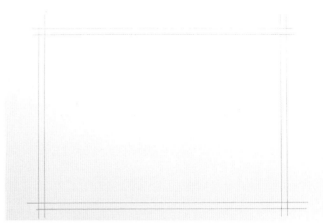

1 Cut the Board to Size
Assemble your supplies before beginning and have everything on hand. Adding on to the width of the mat you plan to use eliminates the need to hinge the artwork to a backing board. In this case, the image area is 7" × 10" (18cm × 25cm), and the mat will be 2" (5cm) on all sides. Cut the board to 11" × 14" (28cm × 36cm), and draw lines 2" (5cm) in on all sides. Then, to make sure no rough edges show in the framed painting, draw a second set of lines one-fourth inch (6mm) outside the actual planned image area (1¾" [4cm] in from the outer edge).

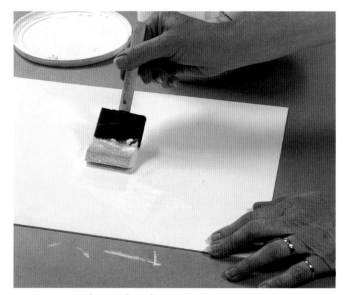

2 Prepare the Back Side
Coat the back of the board (not the side you've marked) with plain gesso using a foam brush. The coat of gesso should be fairly thin, but there's no need to be concerned about direction of strokes. Set the board aside to dry.

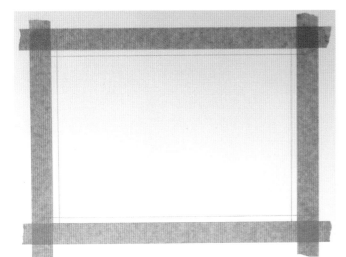

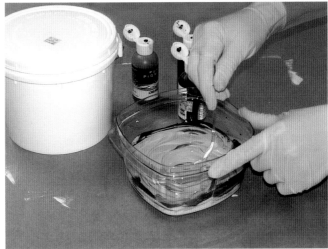

3 Isolate the Area to be Treated

When the back side of the gessoed board is dry (no longer cold to the touch and no wet spots showing when you look at it under a strong light), turn it over. Apply the masking tape to the outer guide line—both the pumice mix and the painting will fill that area, though one-fourth inch (6mm) around all the edges of the painting will be covered by the mat when the painting is framed.

4 Add the Color

Pour gesso into a plastic container with a tight-fitting lid. Add pigment, either liquid acrylic or tube acrylic, stirring well after each addition, until you achieve the desired color.

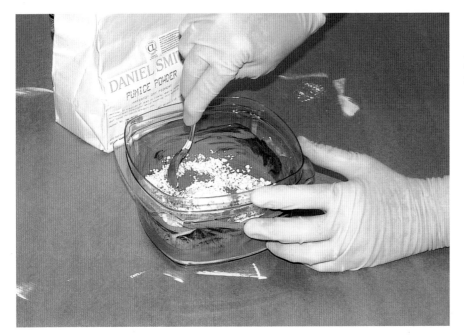

5 Carefully Add the Pumice

Put your mask on and add the pumice carefully, a little at a time, stirring well after each addition.

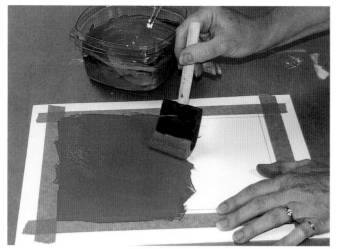 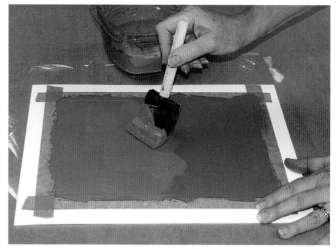

6 Test the Texture, Begin Applying the Mixture

When you think you've reached the desired texture, test it on a scrap piece of mat board, applying a firm stroke with your foam brush. Seal the container of pumice/gesso mix while the test piece dries — it will probably take 30 to 60 minutes. Put your foam brush in a plastic bag, closing tightly around the handle (so you don't have to wash it). When the test piece is dry, feel it or make a mark on it with a pastel; if there's not enough texture, add more pumice to your mix and try again. If there's too much texture, add more gesso. When you're satisfied with the mixture, apply the first coat of the gesso/pumice mix to the masked-off area of your board, using random strokes of the brush. Let it dry completely. Depending on the climate, it may take an hour or two.

7 Add a Second Coat

After the first coat is dry, apply a second coat of the mix, taking care in this step to make sure every portion of the masked-off area is covered. If you should splatter a little mixture outside the masking tape, don't worry—that's the area that will eventually be covered by mat board when your painting is framed.

8 The Finished Product

Let it dry and then remove the masking tape. Now you're ready to put pastel on your new surface. An enlarged close-up view of the finished surface shows the texture created.

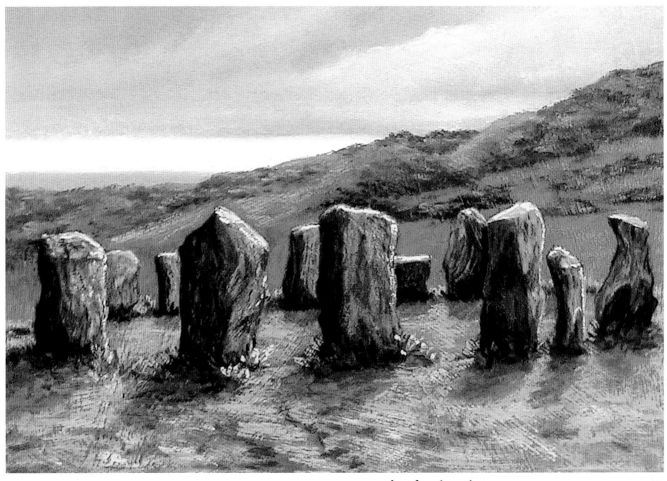

a prepared surface in action

This pastel piece was painted on a prepared surface using the pumice/gesso mix. The texture works to add interest to the rocks, but also adds interest in the grassy areas, where the random strokes both follow and cross the direction of the grass stalks.

Standing Stones, Ireland
7" × 10" (18cm × 25cm)

another type of homemade surface

Artist Sam Goodsell makes a slightly different surface from the one demonstrated on the preceding pages. Instead of pumice, he uses marble dust to create the texture. You may find the resulting surface slightly less gritty than the pumice mix surface. Experiment to see which you like best.

detail
A close-up view of Goodsell's painting shows how the irregular surface affects the strokes.

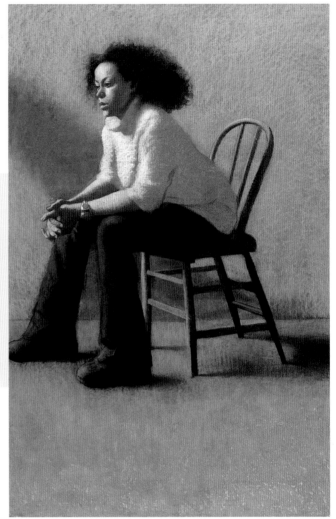

another texture
Sam Goodsell prefers a surface he makes with marble dust, gesso and acrylic paint. This painting shows how the surface texture allows him to build up layers of color, placing general or local colors first and then refining by adding more colors on top of previous layers. A surface with little tooth would not accept this many layers of color.

Lost in Thought
60" × 40" (152cm × 102cm), by Sam Goodsell

a word on fixative

Several brands of workable spray fixative are made specifically for pastels. If you're working on a paper without much tooth and you've filled it to a point that no more pastel will adhere, an application of fixative will let you add at least one more layer. It's also useful when you want to prevent blending—for example, if you decide to add clouds to an already-painted blue sky. Because most fixatives darken the colors of pastel somewhat, you can also use it to deliberately darken or mute colors.

Spray fixative should be applied only outdoors or with adequate ventilation. It doesn't protect pastel from smearing, however, and it's not a substitute for framing your painting under glass, which is the only sure way of protecting it.

working on a colored surface

The color of the surface you're working on can have a dramatic effect on how the pastel pigments appear. The same pastel pigment on a warm surface, such as a red, has a different look on a cool surface, such as a blue or blue-gray. The value of the surface (its lightness or darkness) also affects how the colors appear. Working on a very dark surface generally means you'll need to use much darker pastels in the dark values to get a value contrast in the beginning, which may shift the entire painting to darker values. A neutral value may be the best choice until you're comfortable with value structures. But experimenting with different colors and values will help you understand the medium—and your personal preferences.

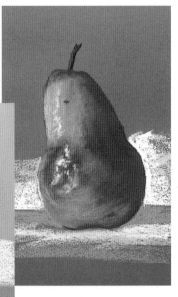

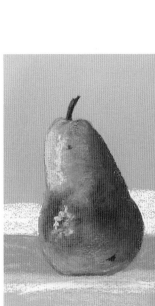

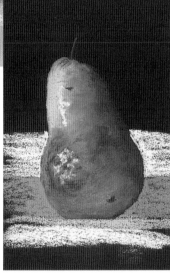

the difference colored paper can make
Look at the difference in these three paintings of the same pear, done with exactly the same pastels. All are on Art Spectrum Colourfix Paper, so the texture is identical—only the color of the background varies from one image to the next.

pastels last for centuries—but will the surface?

If you visit museums displaying pastels painted in the seventeenth and eighteenth centuries, you'll notice that many of them still look as colorful and brilliant as if they had been painted recently. However, in some cases, the paper on which they were painted is deteriorating. Artists in the past often did not have access to high-quality papers that would last for centuries, or they considered their works studies and did not concern themselves with the quality of paper.

Today's artists are fortunate to have a good selection of archival-quality papers and surfaces available, but the terminology can often be confusing. What does it mean to use an archival surface, and why should an artist be concerned with this subject?

The archival quality of a paper refers to how long it will last, and usually the determining factor is whether it is acid-free or not. The more acid in the paper, the faster it will yellow and begin to disintegrate; an old newspaper is a good example of this.

While there's a lot of technical information available about how papers are made, all you really need to concern yourself with is to make sure the paper is labeled acid-free or pH neutral. The pH rating is a way to measure the acid or alkaline content of the paper.

Why worry? Even a beginning artist may create a painting that he or she wishes to keep for many years, or to give to children or grandchildren. Working on a good archival surface ensures that the paper will last through their lifetimes.

Artists who sell their work usually take care to use only acid-free materials in framing as well as the surface upon which they paint, so that the buyer can be assured of the longevity of the purchase. No artist wishes to be in the position of having a buyer return a painting after ten years because the paper is aging!

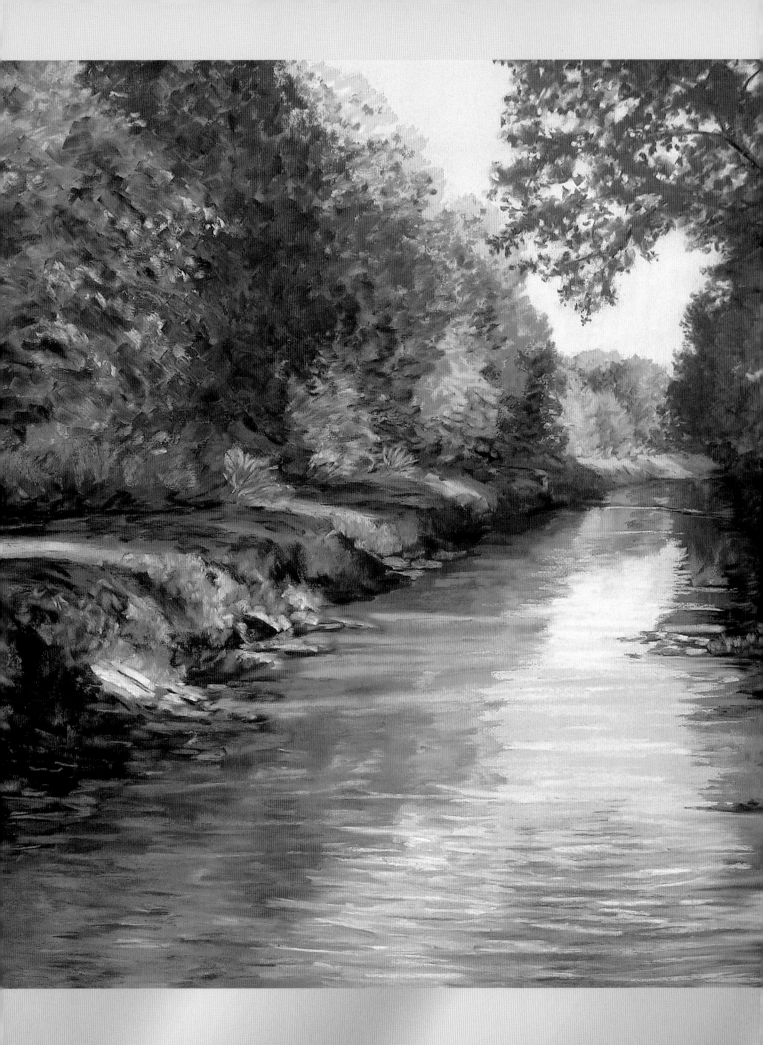

composition and color

Now that you've become familiar with the types of surfaces and pastels available, it's time to consider the composition of your painting. Don't let that blank piece of paper intimidate you—if you approach your painting with a plan to experiment, learn and have fun, it will go much more smoothly. And if you do feel a bit intimidated, don't worry—we all do. When I stand in front of my easel ready to begin a new painting, I take a deep breath and tell myself to remember that it's just a piece of paper, and if the painting doesn't work out, it'll still be a learning experience.

Acequia
17" × 21" (43cm × 53cm)

choosing a subject

The most successful paintings are generally paintings of a subject the painter really likes. If you're not inspired by a subject, it's probably best not to paint it. Look for something that evokes an emotional response, a strong feeling of "I want to paint that!" It's far more likely to be a successful painting than anything you could do with a subject that bores you or leaves you indifferent.

Ask yourself why you like the subject. What is it that draws your attention? That's what the painting should be about. If it's a beautiful tree in a field, then everything you do in the course of the painting should be done to emphasize the tree, the beauty of its lines, the elegance of the foliage and the way the light helps to define its form.

Keep It Simple

Once you're satisfied with your subject and have identified your goal, keep the composition simple. If you're painting that beautiful tree in the field, don't add too many elements. You might include a fence, a gate, a distant mountain or a hillside full of trees—but not all of them. Remember your focus!

Find Your Focal Point

The focal point of a painting will be where the viewer's eye goes first, and it's the artist's job to make that very clear to the viewer. If the eye goes first to an unimportant or distracting element of the painting rather than the subject, the viewer will be less interested in looking at the painting. You've decided to paint a particular subject because there's something interesting or exciting about it—now lead the viewer to it to share your idea.

It's generally a good idea to keep the focal point away from dead center—the painting will be more interesting if you do. But it's also a good idea to keep it away from the edges of the composition, so the viewer's eye won't be led out too quickly. I like to place the focus off-center to the left or right, and up or down a little from center.

The next thing to consider is the format of your painting—will it be horizontal or vertical, and what size? A painting that might work quite well as a vertical may not work at all as a horizontal, and vice versa. Some subjects work well as small paintings, while others demand a larger scale. One way to figure out how to proceed is to make small sketches, or thumbnails, of your subject.

using thumbnail sketches to test your composition

Thumbnail sketches (usually called just thumbnails) are quick, informal, small sketches. I usually draw them at about 2" × 3" (5cm × 8cm) on whatever piece of white paper or sketchbook page is handy. They are often simple line drawings, though they can be value studies or even color studies.

The advantage of the small scale of the thumbnail is that you're reducing the composition to the big elements. You won't draw a lot of detail; your thumbnail sketch may be only a few lines. But it will help you figure out where the big shapes of the composition will work best.

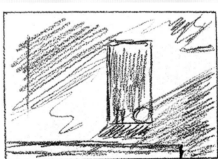

sketch for size and shape
A quick sketch helps you figure out the size and shape of the painting. In this sketch, the window with the vase in it—which is the subject—is a little lost in the composition.

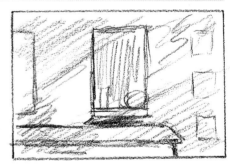

adjust the composition
Increasing the size of the window helps, but the squares on the right and the second window take the focus away from the subject.

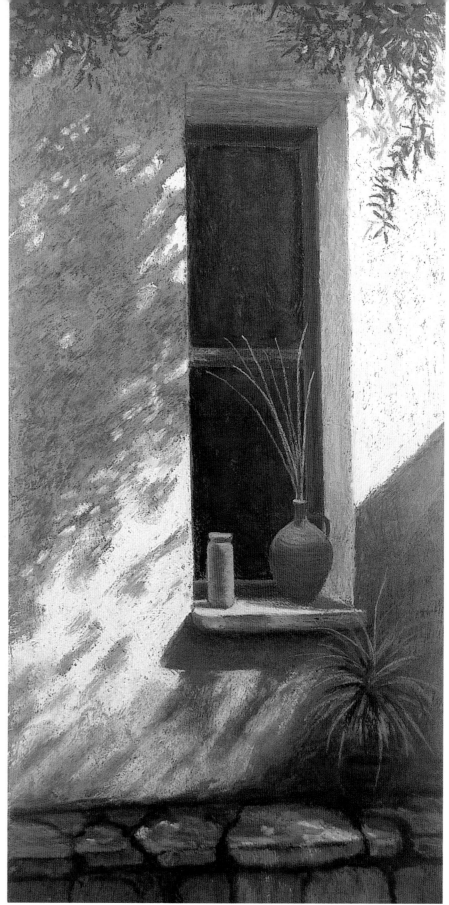

focus in on the subject

Now the focus is on the subject, the window and the vases in it—emphasized by the way the shadow crosses them.

directing the viewer's eye

When you first look at a painting, where does your eye go? Usually, the eye will go to one or more of the following:

- The strongest contrast of dark and light values
- The area of greatest detail
- The juxtaposition of strong complements
- The convergence of diagonal lines

Use these tools to identify your focal point and direct the eye to it.

the right focus

In the painting, the size has been altered to crop in even closer to the window so the shape of the painting emphasizes and echoes the shape of the window. The textured surface, prepared with a pumice/gesso mix, helps emphasize the feeling of the stucco wall in the painting.

In the Window
8" × 16" (20cm × 41cm)

keeping the composition moving

You've told the viewer what the focal point is—now use angles and lines to help direct his eye through the painting. The longer a viewer spends looking at a painting, the more she may find to enjoy in it. Keeping the eye moving around the painting prolongs the pleasure.

As angles and lines can point to the focal point, though, they can also lead the eye out of the painting, so carefully consider the placement of lines. Studying the works of other artists can help you learn to identify the way your eye moves through a painting.

following the path
Whenever a painting includes a road or path, the viewer's eye is most likely to go to that path and follow it. In this painting the path leads to a vertical bush, and the eye follows the bush to its top, then moves left to follow the line of the arching pink wall. The branches of the white plant in the lower left corner arc up toward the wall in such a way that the eye, following the arc of the wall, will then move down the arc of the plant and back to the road.

Garden at Los Golondrinas
5" × 7" (13cm × 18cm)

sketch the big stuff
Keep your thumbnail sketches simple, including only the largest elements of the composition. The thumbnail will help you identify compositional problems—it's not meant to be great art in itself. This sketch helps you see that the path of the stream goes too directly back to the distant mountains.

improve your composition
A winding stream, path or road is more interesting than a straight one. Making a thumbnail sketch before beginning a painting can help you make compositional decisions and improve the design of the painting.

maintaining balance

Balance helps make a composition pleasing to the eye. If you have a large, dark shape dominating one side of the composition, find another shape that can balance it so the composition does not feel as if it's falling over to one side.

There's a difference between balance and symmetry. Balance can be symmetrical, but more often it is not. Unequal divisions are more interesting than equal ones, so you should strive for balance rather then symmetry. For example, avoid putting the horizon line in a position that divides the painting equally between sky and land. Likewise, a painting that is either predominantly dark or light, or warm or cool, is more interesting than one that has an equal balance of elements. As you consider your subject, think about how you can use these concepts to create a strong composition.

the importance of value

Value is the relative darkness or lightness of a color. In Europe, the word tone is used instead of value, and in some ways that term makes more sense.

Our understanding of the shapes of things is based on values. Light falling on the surfaces of objects and the shadows resulting from the areas where the light does not fall gives us a basis for interpreting the form. From infancy, we learn to understand the world around us through understanding form described by light.

Your eye can see gradations of many, many variations in relative lightness or darkness, which as artists we understand as a range of values. But even if you have hundreds of pastels, you don't have a range of values in pastel that is anywhere near what your eyes can see. So in structuring a painting, you have to compress the number of values you can see into the number of values you will include in your painting.

This is generally an intuitive process, but you might understand it better if you analyze it once—you probably don't have to think it through for every painting. For example, if you can differentiate twenty or thirty distinct value steps in the landscape before you, but plan to structure your painting using 8 values, you may group the three or four lightest values and assign them to value 10; the next group of light values would assign to value 9, and so on. This is compressing the values from the visible to the actual range you will use in your painting.

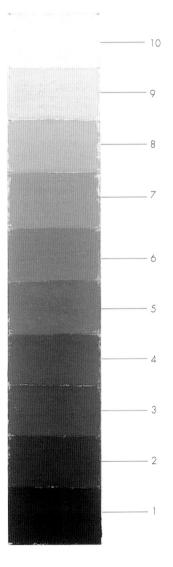

identify the major values
Your thumbnail sketch can be limited to two values—the white of the paper and a value that stands for medium-dark to dark. This will help you identify the major light/dark masses in the composition.

finding the values
Your thumbnail sketch can also break the composition into several values, from the white of the paper, which stands for the lightest values, through several gradations of darker values.

using values
The ten-value scale is most commonly used to differentiate values in painting. You do not need to use every value in a painting—a high-key (very light) painting may not have any values darker than number 4 or 5, and a low-key (very dark) painting may not have values lighter than a 7 or 8.

maintaining a strong value structure

A strong value structure is possibly the most important part of a painting. A painting with a strong value structure has large, clearly defined areas of the major values, while a weaker painting may have small shapes of many values scattered throughout. Before painting, make a thumbnail sketch to identify just three to five values in large shapes; this sketch will help you maintain a strong value structure. As you develop the painting, you may break these large shapes into smaller shapes of closely related values, but the strong structure at the beginning will help prevent the values from being scattered throughout the composition.

If you're working on sanded paper or a heavily textured surface, you can draw your composition onto the paper with extra-soft vine charcoal, using the charcoal to identify the major values. Because the darkest applications of charcoal will be in the area where the darkest pastels will be applied, you don't have to worry about the charcoal muddying the pastels. Let your paper be the lightest values, and when you have completed your charcoal sketch, step back to see if you

have a pleasing balance of values, and if they group together to create large shapes of similar values. If so, proceed to your painting. (If you're working on a less-toothy surface than sandpaper, give the charcoal a light application of fixative.)

If you work on a toned surface of a middle value, you can use your charcoal for the darkest values, and a light application of a light value pastel (a NuPastel would work well, since it won't fill the tooth) for the lighter values. Let the paper stand for the middle value. This will give you a clear value structure to follow as you begin the painting.

As you begin to apply pastel to paper, it's helpful to identify the lightest and darkest value you see in the composition. Choose a pastel to represent each of those values and place a mark of each in an appropriate area of light or dark. Leave the pastels out on your "working palette" (those pastels you're using in the painting) and compare subsequent sticks as you select them, ensuring that no other value will be lighter than the lightest light you've identified, or darker than the darkest dark.

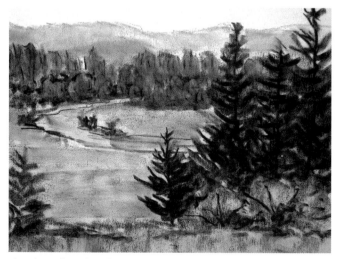

simple value sketch on white paper
A charcoal drawing on white Wallis Sanded Pastel Paper shows a simple value structure. The darkest dark values are in the group of pine trees in the foreground right and the single pine in the foreground left. The next darkest dark values are the foreground bushes and grasses, and the trees in the middle distance. The lightest light is the sky, with the next lightest lights in the two distant mountain ranges and the river. Middle values are used for the plains surrounding the river. Following this value structure as the painting progresses will keep the values clear and simple.

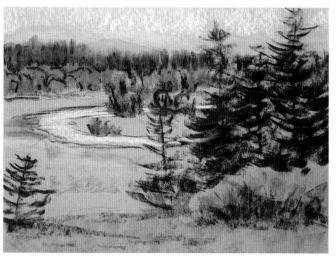

use a neutral tone for middle values
This sketch shows a simple value structure, with the neutral beige color of the paper used for middle values. Like the sketch on white paper, the darkest darks are sketched in with charcoal, but in addition the very lightest lights are indicated with two values of light gray.

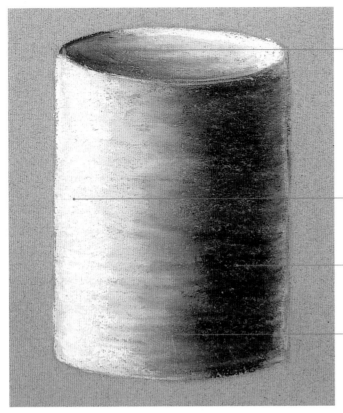

Because the light is coming from the left, there is a shadow on the inside of the cylinder, which is darkest at the left and moves through halftone or middle values to a light value on the right.

The lightest light value is on the outside of the cylinder.

The darkest dark value is the shadow on the outside of the cylinder.

The halftone area is where the values meet, moving from light to dark. This transition of light to dark describes the form.

halftone areas

Keep in mind that the progression from dark to light includes halftone areas. If you've taken any art classes, you probably remember the exercise of drawing a simple cylinder. The cylinder was lightest in value on the side closest to the light, and darkest on the side farthest from the light source. In between those values, there is a progression that moves in each direction to the halftone—an area that is pretty much half dark and half light. That progression from light to halftone to dark described the shape of the cylinder, and can also describe rounded objects such as arms, tree branches or even mountains.

color definitions

- *Value* is the relative lightness or darkness of an object. In a black-and-white photograph, you can see what objects are lighter or darker than others. A value scale is a visual aid to determine value, which is much harder to see in color. Usually these scales (available at art supply stores) are in ten steps, with black being Value 1 and white being Value 10. (See page 37)

- *Color temperature* refers to the warm or cool characteristics of a color. In general, reds and yellows are warm, and blues are cool. However, more subtle colors may appear warm or cool depending on the surrounding colors. In a predominantly red-yellow painting, purple may appear cool, while in a predominantly blue area, the red pigment in the purple may make it appear warm next to the blues. In general, cool colors recede, and warm colors come forward.

- *Local color* describes the actual color of an object. For instance, the local color of foliage is generally green. The highlights could be yellow-green, and the shadows blue-green.

cast shadows

Don't confuse the value of the shadowed side of an object with a cast shadow. The value of a cast shadow is darkest closest to the object that casts it, but rarely darker than the shadowed side of the object. As the shadow moves away from the object casting it, it diffuses and becomes lighter in value. Careful observation of the values of shadows and cast shadows will help you describe them accurately in your paintings.

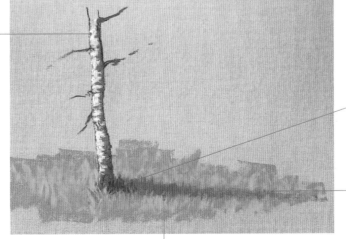

The light strikes the tree trunk on the left side of the tree.

The deepest shadow value is closest to the tree trunk.

As the shadow moves away from the tree trunk, it diffuses, becoming lighter in value.

Note that the edges of the shadow do not make a crisp, hard line. Some blades of grass actually stick up in front of the shadow, breaking up the shadow shape.

strengthen your painting values

Simple value structures make a painting more striking than a complex one—think about how you can limit the number of values used. A technique artists call "massing the values" helps create a strong composition. If you have adjacent areas of very close values, mass them together and assign one value to the mass; if you have a value broken by spots of another value, leave out the spots and make it all one value. This will simplify and strengthen your composition.

Color, Value, or Temperature?

No matter how many pastels you have, sooner or later you'll be working on a painting and find yourself without the exact color. Value is more important than color, though, so try a pastel of the correct value even if it's the wrong color. You may be amazed and pleased at the result.

Color temperature is also more important than the correct color. When you don't have exactly the right color, try another color that is both the right value and temperature. For example, if you need a green of a particular value for a foreground area of foliage, pick a yellow-green of the correct value. A blue-green of the same value would make your foreground recede rather than come forward. Remember, warm temperatures generally come forward in a painting, while cool colors tend to recede.

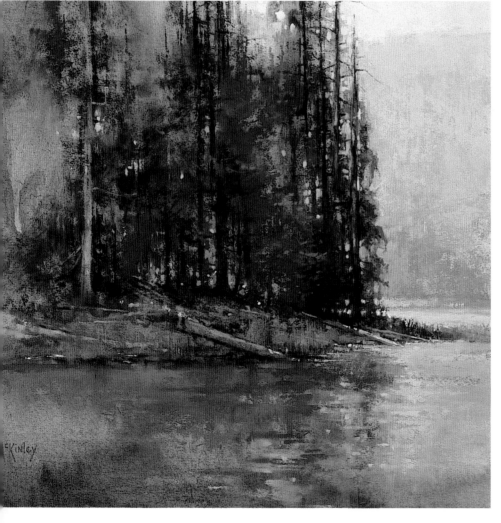

using temperature to come forward or recede

This painting illustrates how the correct value and temperature of a color are more important than the "right" color. Look at the colors in the trees. We know that trees are green, but there are blues and purples in the shadowed foliage that make it appear farther away from the viewer. The correct values and the cool temperature of these shadowed areas make the color read correctly.

The Cove
14" × 14" (36cm × 36cm) by Richard McKinley

using color

Your use of color will define the mood of the painting. Think about how you relate to color. Blues and cool greens usually evoke feelings of tranquility; reds, magentas and oranges often indicate excitement. You can approach the use of color in an intuitive way—painting what you see and what you feel as you look at your subject—or you can approach it more systematically, choosing a color scheme in advance. Both approaches are valid; try each and see which suits your style.

The Color Wheel

Primary colors are the three basic colors which cannot be made from any other colors: red, yellow and blue. Secondary colors are the colors that can be mixed from two of the primaries—orange, purple and green—and tertiary colors are mixed from a combination of primaries and secondaries (such as yellow-green or red-violet).

You can use the color wheel to identify complements and analogous colors. **Complementary colors** are the colors opposite each other on the color wheel. Most people think of the complements of primary and secondary colors when they think of complements: yellow and violet, blue and orange,

red and green. But don't neglect the tertiary colors—try using complements like yellow-green and red-violet, or blue-green and red-orange. These pairs may be a little less obvious, but they are still strong.

If a pair of complements is too strong for your composition (and they can be very strong—complements placed next to each other will stand out, while complements mixed together will result in gray), consider another option. Instead of yellow and violet, which are true complements, try yellow and the two tertiary colors next to violet, blue-violet and red-violet.

Harmonious triads are created using any three colors whose position on the color wheel forms an equilateral triangle. The primary colors of red, blue and yellow are one combination, but consider less obvious groups such as red-orange, blue-violet and yellow-green.

Analogous colors are colors adjacent on the color wheel. Pick any two or three colors next to each other on the wheel and the hue they have in common will create harmony. For example, if you use violet, blue-violet and blue, they have blue in common, and though each is a separate color, they will be harmonious.

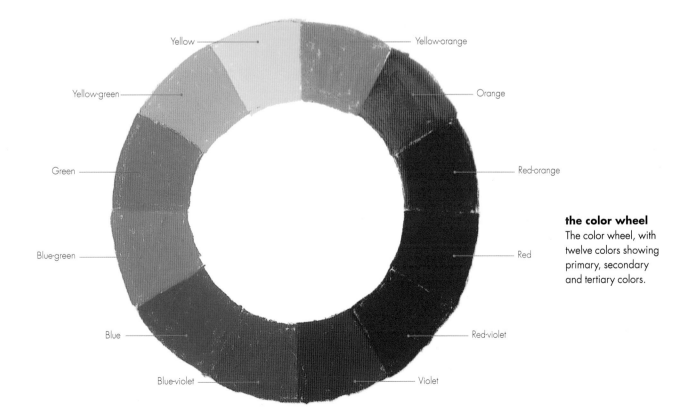

the color wheel
The color wheel, with twelve colors showing primary, secondary and tertiary colors.

designing with color

Designing with color can be done many different ways, but here are a few tried and true methods.

Using Complementary Colors

Try creating a painting based on complementary colors. That doesn't mean every color must be a pure color (red, blue or yellow), but rather in the same color family. Orange and blue or yellow and violet are good pair choices for landscape paintings. Keep in mind that the definition of a color is subjective and relates to that painting—what you might put in the orange family in a painting based on the blue-orange complement could go in the yellow family when you're working with yellow and violet.

Sometimes Less Is More

Limiting the number of colors in a painting is another way to create harmony. Try picking out about twenty sticks in the color scheme you've chosen for a painting. As you work, if you feel you need an additional color, see if it's possible to use a stick of the correct value and temperature instead. Most pastel artists have hundreds of pastels but use only thirty or even fewer per painting.

Creating Depth With Color Temperature

The effects of temperature can be easily seen in landscapes—it's a basic premise in painting that cool colors appear to recede and warm colors move forward, and this effect is obvious outdoors. Distant hills are bluer than close ones; in general, as you view objects in the distance, they are bluer, grayer and lighter in value than foreground objects.

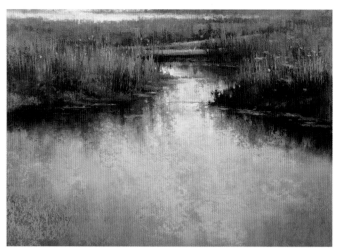

harmony through a limited palette
This painting by Richard McKinley is a good illustration of a limited palette used to create harmony in a painting. The analogous colors of blues, purple-blues and lavenders are complemented by the yellow-greens in the grasses.

Evening on the Marsh
12" x 16" (30cm x 41cm)
by Richard McKinley

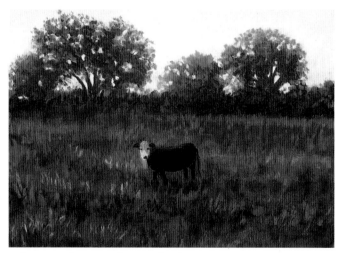

using complements for emphasis
This painting is predominantly oranges. The late evening light colors the entire landscape. Note how the cow's face, with its spot of blue, stands out in the midst of all the oranges.

Curious Cow
5" x 8" (13cm x 20cm)

using broken color

Broken color—areas that appear textured due to numerous sudden changes of value—is a wonderful tool for the pastelist. When you have a fairly large area to fill, select two or three colors of the same value and apply them with small strokes next to and overlapping each other. The result is exciting color and texture instead of a bland, boring area.

broken colors create foliage
This shadowed area of foliage in one of my paintings could have all been a boring dark green. Instead, I chose to use a number of colors—greens, blues, browns and even purples—in broken color to represent the foliage. It's much more effective and exciting.
Detail from *Smith River Reflections*
17" x 23" (43cm x 58cm)

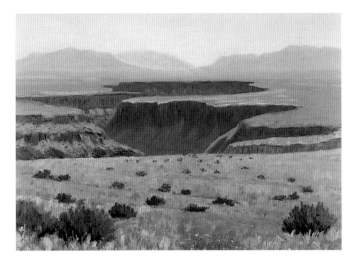

Using these color effects can give a feeling of distance in even very small paintings. Keep your warm colors—yellows and reds in particular—in the foreground, and if those colors do appear in the middle ground or distance, choose bluer or grayer versions of the colors.

Using Contrast

The effective use of contrasts can be the basis for a great painting. Think about how you can use the following:

- **Contrasts of light and dark values.** Contrasting values creates form and space. Remember to save the contrast of the lightest light and the darkest dark in the painting for your focal point.
- **Contrasts of warm and cool colors.** In general, cool colors recede and warm colors move forward; use this to create depth between the foreground and background of your paintings.
- **Contrasts of lost and found edges.** If every object in your painting has a hard, distinct, "found" edge, then there is no contrast. Let some edges be lost or softened so that the distinct edges have more impact.
- **Contrasts of detail and simplicity.** Keep big, simple shapes for the background and middle ground areas, or areas of less importance, and save the details for the areas of greatest interest.

As you look at the paintings in this book and elsewhere, try to identify how each artist has used contrasts. The more familiar you become with how contrasts are used, the easier it will be to apply them in your own paintings.

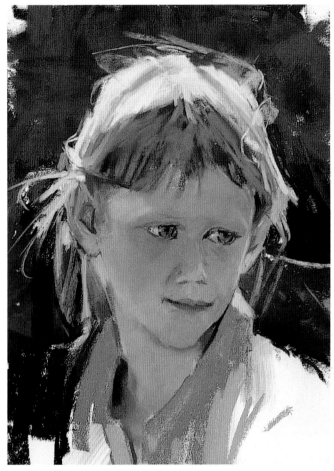

using contrasts
This portrait nicely illustrates the use of contrasts. Note the contrasts of warm and cool as well as complements (warm reds and cool greens) and the contrasts of light and dark around the girl's face, which add depth to the painting.

Catrina
9" × 12" (23cm × 30cm) by Bill Hosner

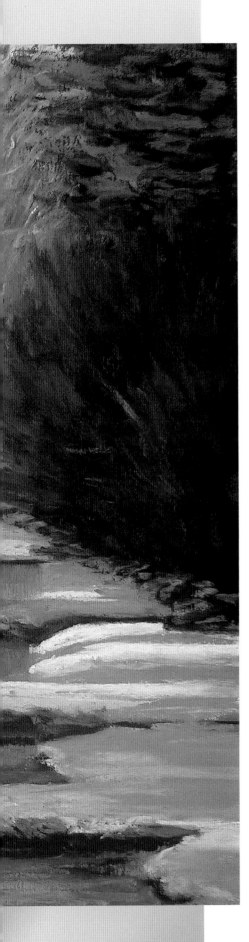

putting pastel to paper

There are probably as many techniques of applying pastel as there are artists using the medium. You'll develop your own techniques as you become familiar with the way pastels behave, but the methods demonstrated in this chapter will give you a starting point.

Many of these techniques were used in creating the painting on the opposite page. It began with a brilliant color underpainting—one of several underpainting techniques we'll explore. The distant trees and foliage on the bank were created using broken color, tapping slightly to merge the colors. Rubber-tipped paint shaper tools were also used to blend some of those colors. A variety of strokes were used—pastels were applied held on the side except when making lines, which were drawn with tips or corners. Finally, the water was painted using light strokes of pastels held on their sides; the reflections were blended, layered and blended again, after which the blue water was added in the foreground.

Blanco Winter
11" x 14" (28cm x 36cm)

making strokes

Applying pastel to paper is as simple as picking up a stick and making a mark. Unlike wet mediums, there's no need to mix a color—just select one and go! However, there are many ways of making those marks, as you'll discover as you experiment with these methods and others you'll develop on your own. There's no "wrong" way to use pastels, so don't hesitate to try whatever you think might work.

How you hold the stick—point down, on edge, on its side—affects how the mark or stroke appears. Varying pressure also affects the appearance of the mark as well as the coverage or even the color on the paper. Trying these techniques will help you understand the feeling of the strokes as well as the results.

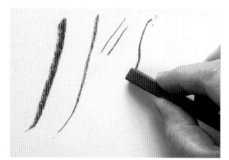

varying the pressure
Harder or firmer pastels can be used for drawing lines and making small strokes. If you vary the pressure as you make the mark, you can create thick or thin strokes. The pastel used here is from the Faber-Castell Polychromos set.

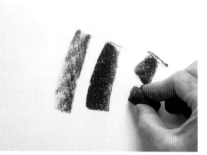

holding pastels on their side
When you hold a pastel stick on its side, you create a wide stroke. Again, varying the pressure allows you to lightly glaze or heavily apply a layer of color over the surface.

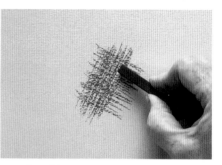

crosshatching
Use crosshatching to cover a surface with strokes in two directions. This method is particularly effective if you're working on a surface with very little tooth, such as the Canson Mi-Teintes paper shown here. You'll be able to get a nice, solid color without over-filling the grain of the paper.

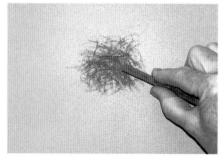

weaving lines
Weaving lines can be used to cover the surface with multiple colors in random directions. Unlike cross-hatching, this creates a varied and some-what textural surface, and you can use as many colors as your surface will allow. This technique lets you build exciting colors up on areas that might otherwise be flat and boring if painted with a single color.

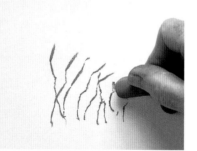

rolling strokes
Using a rolling stroke with a round, soft pastel creates an uneven line. This is useful when your subject includes things like reeds or grasses or even tree branches—the rolling stroke keeps you from getting too repetitive and regular—and it's fun to do.

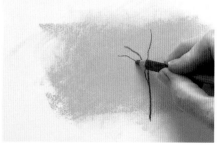

pastel pencils
Very fine lines can be created with pastel pencils. They're especially useful for thin, sharp lines; for example, you might use them to place thin branches over an already-painted sky. But be careful not to overuse them: Your painting could look more like a drawing, or have too much detail.

layering to create texture

Desmond O'Hagan uses layering to create texture, varying the pressure as he applies the color. Lighter pressure applies a "skim" of color, while a heavier pressure applies a more intense, heavy coverage.

Madrid at Dusk
9" × 12" (23cm × 30cm) by Desmond O'Hagan

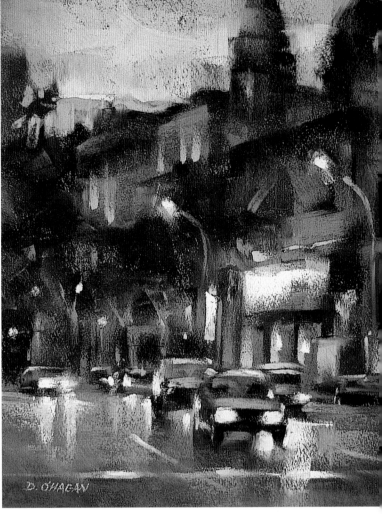

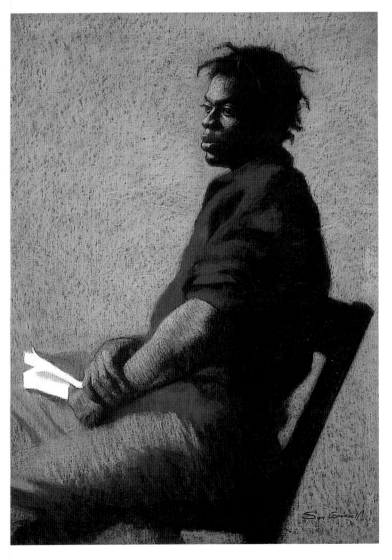

variety of strokes

Sam Goodsell uses a variety of strokes and lines to create the form. Note that some of his strokes, rather than being broad passages of color created with the sides of the pastels, are more linear, and the weaving and layering of the lines and small strokes create the form.

Knowledge is Power
40" × 30" (102cm × 76cm) by Sam Goodsell

tools for blending

A number of tools are available for blending to soften edges, move color and mix it on the paper. In addition to tools sold commercially for these purposes, there are things you may have in your home that work well for blending. Styrofoam peanuts, the "core" of Fome-Cor (cut a piece off, remove the paper from the front and back, and you have a firm blending tool that can be cut to any size or shape) or even eyeshadow applicators all make good blending tools.

Layering Color

Use layers of pastels over other pastels to blend colors. When you don't have the color you want, you can create it with layers of colors. You can also layer and intermix colors for optical blending effects, or to create broken color (small strokes of several colors of the same value applied to an area, layered and side-by-side, to create interesting color).

paint shapers
A rubber-tipped paint shaper is similar to a paintbrush, except the "brush" is a rubber shape with some broad edges and some narrow edges. They work well to blend colors, and can also remove color. I use the Colour Shaper brand.

tortillions
Tortillions, or stumps, are traditional pastel and charcoal blending tools. Their fine points can get into small spaces and push the pastel into the paper.

pastel pencils and charcoal
You can use thin sticks of extra-soft vine charcoal or pastel pencils to feather edges. Hold the stick or pencil far back from the point and fan it gently across an area you wish to blend. Using charcoal may gray the color a little, while using pastel pencils may glaze on a little extra color as it blends your pastel pigments.

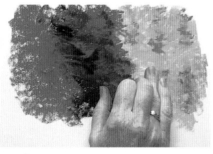

tapping
Create soft edges by tapping the pastel with your fingers. Unlike blending, tapping does not muddy colors but can be useful for softening edges or melding two or more colors together.

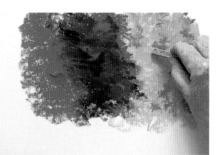

layering
Layering hard pastel over soft is one way to blend while adding color. Try this in an area of foliage: With very soft pastels, put down several greens, perhaps add some oranges, and then lightly stroke over the soft pastels with the side or tip of a firm yellow or yellow-orange pastel. The harder pastel will blend the colors together while adding the impression of sunlight. You can create a similar effect in shadowed areas by using soft pastels in dark colors and then blending with a blue or blue-green hard pastel.

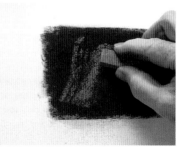

glazing
Glazing with a stroke of soft pastel, holding the stick on its side, is a way to layer color without blending. Where the layer is thinnest, the effect of a different color is created.

blending reflections in water

Reflections in water are a fascinating subject. Whether the reflections are a crystal-clear mirror image, or whether gentle ripples distort them, they add depth and dimension to a landscape painting.

Unlike a shadow, which can cross the water at an angle, reflections always come towards the viewer. Assume the viewer is standing in front of the center of the painting, and paint the reflections accordingly.

materials list

White Wallis Sanded Pastel Paper

pastels

middle-value cool blues; light, middle and dark values of yellow-green; middle and dark greens; dark blue-green.

Also, note that very light colors tend to reflect darker, and very dark colors reflect lighter in value.

Color and depth of water also affect reflections. Very shallow water will pick up some color of the sand or rocks below; very deep water will likely pick up the deep blue reflection of the overhead sky.

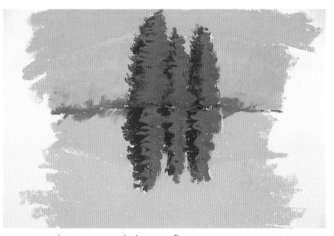

1 Paint the Trees and Their Reflections
At the same time you paint the land mass to be reflected, paint its reflection. Pay attention to how much or how little of the land mass is reflected. The angles of hillsides, the distance of the trees from the edge of the water and the angle of view all help determine what is and isn't reflected, so careful observation is important.

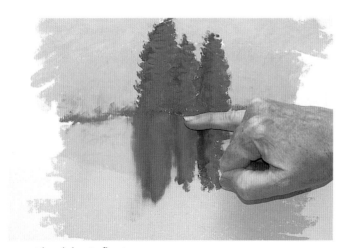

2 Blend the Reflection
Using the side of your finger or the side of your hand, blend with a quick, firm downward stroke, beginning at the edge of the water. It's OK if you need to make a second blending stroke in a particular area, but don't overblend or the colors will get muddy.

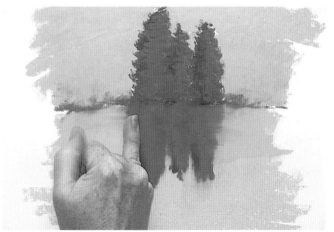

3 Add a Horizontal Stroke
Adding a horizontal blending stroke makes the water lie down flat. Use a light touch to avoid losing the effect of the vertical stroke.

beginning with an underpainting

Covering your surface with an underpainting can be useful in many ways. An underpainting can establish preliminary values, and as you layer color over it you can allow some of the underpainting to show through to add excitement. Try these methods of underpainting to see what works best for your subjects.

Underpainting with the Local Color

If you begin with an underpainting of local color (the object's actual color, like the red of an apple not made blue with shadows or white with reflected light), you can quickly establish large shapes and value patterns. Block in big shapes of color in accurate values, then stand back and analyze the structure of color and value—if you aren't happy with it, it can be changed easily at this point. Keep your first application of pastel thin so you don't fill the tooth of the paper.

Making Changes

Pastel is probably the easiest medium in which to make changes. If you discover you need to change an area of a painting, even if it's as much as half the composition, you can simply remove the pastel and begin again.

The methods for removing pastel depend in part on the surface you're working on. One of the best tools for removing pastel from sanded paper or smoother-textured paper is a foam brush—the kind you buy at the hardware store for applying paint.

Take the painting outside if possible, or work in a well-ventilated area, hold the painting (still on its backing board) vertically, and brush the pastel from the paper in the area where you need to make revisions. It may take several passes with the brush, and you may need to sharply tap the brush against the waste receptacle into which you're brushing the

materials list

White Professional Grade Wallis Sanded Pastel Paper

Turpenoid™

No. 8 filbert brush

pastel pencils

middle-value or dark yellow-orange, light brown, dark brown

pastels

light-value yellow, middle-value yellow, middle-value yellow-orange, middle-value peachy orange, middle-value orange, very light cool blue, light cool blue, middle-value cool blue, dark cool blue, light brown, middle-value brown, dark warm brown, mauve-brown, dark purple-brown, light blue-gray, light yellow-gray, middle-value beige-gray, light yellow-green, middle-value yellow-green, bright middle-value green, middle-value green, dark green, dark blue-green, bright red

1 Begin with a Local Color Underpainting

Deborah Christensen Secor began this painting on white Wallis Sanded Pastel Paper with a loose local color underpainting.

2 Foreground Altered

As she began working with the next application of color, Secor decided to make a change in the foreground after the first layer of color was applied, so she rubbed out the foreground.

pastel dust, but you should be able to remove almost all the pastel from the surface.

Sanded paper, such as Wallis Paper or Art Spectrum Colourfix, will allow you to take one more step. If you've brushed off everything you can but still aren't satisfied with the tooth remaining, lay the paper (on its backing board) flat on a table, and carefully drip a few drops of Turpenoid™ in the area where you're removing pastel. Using a corner of a paper towel, rub it into the area and then lift off. Once the surface is dry, you can begin again.

Note that none of these methods will remove every bit of pastel, and a "ghost" of the previous image may remain. But if the tooth has been recovered, that's all that's neces-sary to let you apply a new layer or layers of pastel and make your changes.

If not enough pastel comes off, or if you're working on a very heavily textured surface such as a pumice/gesso pre-pared board, try an old toothbrush (dry). The stiffer bristles will remove more pastel.

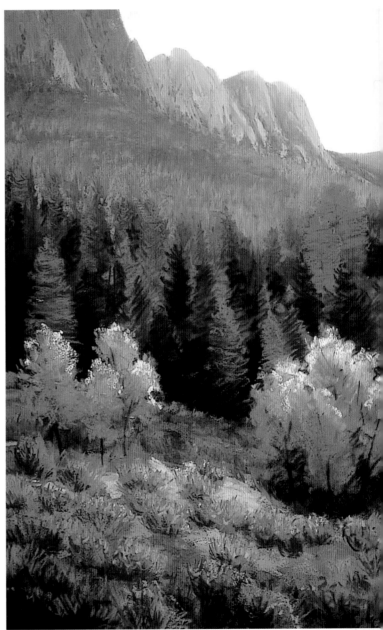

3 More Changes

Studying the painting at this point, Secor decided to make a revision to the trees on the left of the painting and rubbed them out.

4 The Advantage of Underpainting

Beginning with an underpainting allowed changes to be made early on while retaining the basic structure of the painting. The underpainting also set the pattern of basic colors and val-ues, which were strengthened as the painting evolved.

Light from Above
18" x 11" (46cm x 28cm) by Deborah Christensen Secor

underpainting of complementary colors

Complementary colors can help create exciting, lively paintings. When you're working on a subject that's a bit dull, or a subject that has one dominant color, such as a mass of green trees, a complementary color underpainting adds sparkle. Begin with a single sketch, then block in the large shapes in complementary colors. (This first application of color is often referred to as the "block-in.")

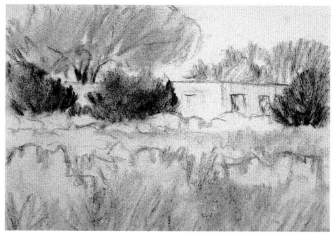

Artist Deborah Christensen Secor began with a simple sketch of her subject in charcoal on La Carte paper.

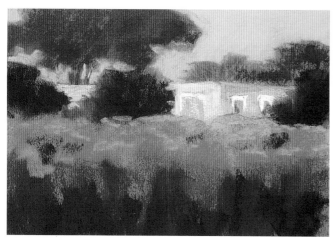

BEFORE
underpaint with the complement
The block-in of the painting was applied in complementary colors.

using complementary colors
Complementary colors appear opposite each other on the color wheel (for example, red and green are complements). Complements appear vibrant next to one another and can be mixed by layering to create lovely neutral grays.

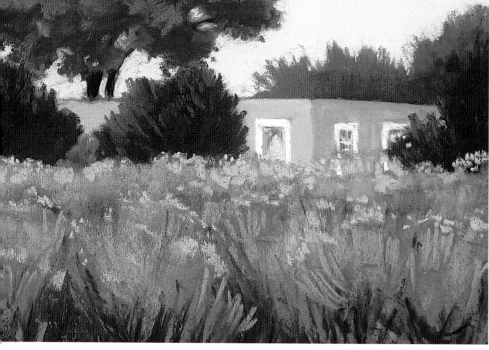

AFTER
finish the painting
The finished painting has a liveliness and glow from the complementary color underpainting, created by allowing little flecks of the oranges from the underpainting to show through here and there. A complementary color underpainting will enhance the subsequent layers of pastel, particularly when the subject has lots of greens.

Chamisa Garden
6" × 8" (15cm × 20cm) by Deborah Christensen Secor

using a brilliant underpainting

If you're working from photos, using a bright, brilliant underpainting can be an easy way to bring life to your painting, particularly if the photo's subject is dull, under-exposed or overexposed. In this case, the subject wasn't particularly dull but I wanted to emphasize the brilliant colors visible in the water, which I remembered as less muted than in the photograph.

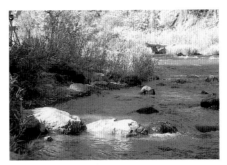

reference photo
The original photograph hints at the colors in the water that I remembered.

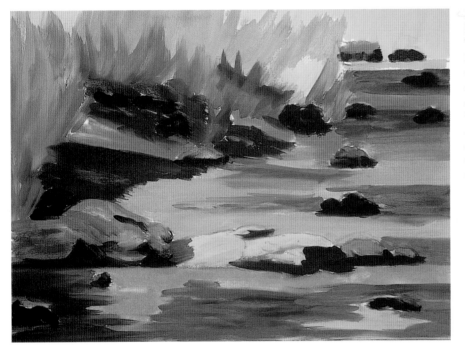

BEFORE
block in with bright colors
The painting is done on White Wallis Sanded Paper. When you block in the underpainting using this brilliant color method, exaggerate every color—for example, paint a dull beige or brown in a shocking orange. A hint of pink becomes a bright pink; a soft yellow-green should be underpainted in lime. It's always easier to mute a strong or intense color than it is to intensify a dull color, so start with brilliance! Once the pastel is blocked in, brush it with Turpenoid™ and let it dry.

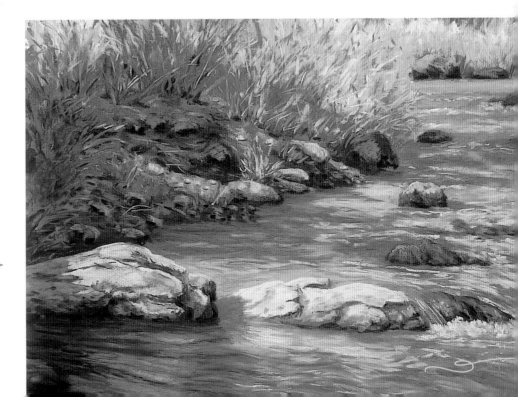

AFTER
add the more muted finish
As you apply another layer of pastels in more accurate colors, let a little of the brilliant underpainting show through. The finished painting has far more life and excitement than the photograph, thanks to the underpainting.

Sunlit Stream
11" x 14" (28cm x 36cm)

underpainting sunlight and shadow

When you look at a photo, it can be hard to tell the difference between a dark-colored object and a dark shadow. I've developed an underpainting method that will not only help you clarify these differences, but add light and life to your paintings done from photo references.

As a general rule, on a sunny day, colors in sunlight are lighter in value than colors in shadow. The darkest color in full sunlight will appear lighter in value than the lightest color in full shadow. This simple method helps you analyze areas of sunlight and shadow, and keep your values (light and dark) and temperature (warm and cool) clear throughout the painting.

analyzing the reference photo
This photograph has a distinct sunlight and shadow pattern. It could be confusing to establish values without an underpainting, as there is light-colored foliage in full shadow, and dark-colored foliage in sunlight. Use your underpainting to establish the value structure of the piece.

materials list

White Professional Grade Wallis Sanded Pastel Paper

Turpenoid™

No. 8 filbert brush

pastel pencils

middle-value or dark yellow-orange, light brown, dark brown

pastels

light-value yellow, middle-value yellow, middle-value yellow-orange, middle-value peachy orange, middle-value orange, very light cool blue, light cool blue, middle-value cool blue, dark cool blue, light brown, middle-value brown, dark warm brown, mauve-brown, dark purple-brown, light blue-gray, light yellow-gray, middle-value beige-gray, light yellow-green, middle-value yellow-green, bright middle-value green, middle-value green, dark green, dark blue-green, bright red

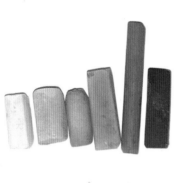

1 Choose Six Pastels

The three lightest values should be in the yellow/orange family and the three darkest values in the blue family. The values move from the lightest yellow to the darkest blue. Note that even the lightest blue is darker than the darkest yellow. To confirm that your value progression is accurate, make swatches of the colors you've chosen adjoining each other on white paper. If you can see a difference in light/dark relationships, then there is a value difference.

2 Lightly Sketch Your Subject

Using a yellow or orange pastel pencil, sketch the major lines and positions of the subject. Use the minimum number of lines necessary, as everything you sketch will be covered by the underpainting. Indicate only the largest shapes and critical items, such as tree trunks. Don't worry about small shapes like small branches at this point.

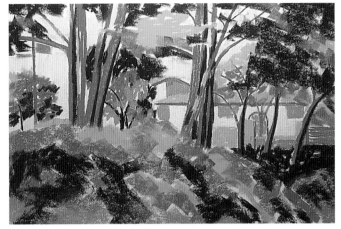
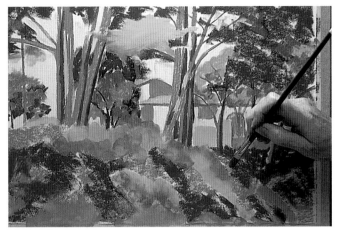

3 Make the Initial Block-In

With your six pastels, block in the big shapes of the painting using the sides of the pastels. Use a light touch. Begin with the sunlight (yellow and orange) colors. All areas in sunlight will be in one of the three values of yellow/orange. Even though your photo may show the sky as blue, for example, it should be blocked in with the lightest yellow since it is the source of sunlight. All areas in shadow will be in one of the three values of blue. Keep your shapes large—if a mass of shadow is broken by small areas of sunlight, ignore the small areas of sunlight for now and just block in the large shadow mass.

Normally, you'll work dark to light in pastels. For this particular underpainting method, though, starting with the yellows will allow you to make corrections.

Remember that the local color, the actual color of these objects, is unimportant at this stage. Think sunlight or shadow—which of the three values of sunlight or shadow you will use—and keep your shapes big.

4 Wash the Painting with Turpenoid™

When the initial block-in is complete, brush the pastel into the surface of the paper with a brush and Turpenoid™. Use a fairly small flat or round inexpensive synthetic brush, or an old brush you don't care about, since the sanded surface will wear out a brush very quickly. Keep your brush clean, wiping frequently on a paper towel; if you wipe the brush after every stroke, you'll keep from inadvertently mixing colors. Start with the lightest light yellow, then move to the next value of yellow and continue through each darker value, keeping your brush as clean as possible. If runs occur, dab them off with a paper towel. When all areas have been washed with the Turpenoid™, dry the piece with a hair dryer or set it aside until it's completely dry.

from darker to lighter

When the Turpenoid™ wash is completely applied, the colors of the pastel will appear darker than when they were dry (left). They will lighten as they dry (right).

Set your painting aside to dry. You can speed this up by setting it in sunlight, or dry the underpainting with a hair dryer. Use low or medium heat, holding it at an angle several inches from the surface and drying the painting evenly. You'll see the color lighten as it dries. Depending on how much Turpenoid™ you used, it should take only a few minutes to dry. Touch the surface with your finger, and if the paper feels damp or oily, it's not dry yet.

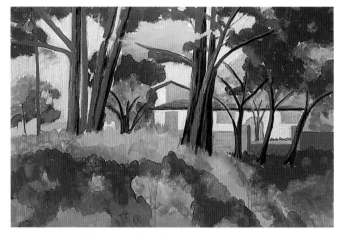

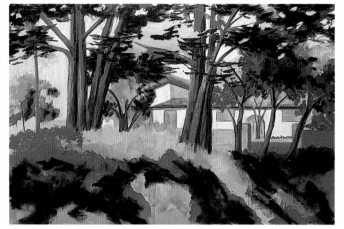

5 Begin Adding Local Color

Begin to add realistic color. Working from the background (distance) forward allows you to lay objects or shapes in the foreground atop background objects. For this reason, and because the value of the sky helps you establish other values in relation to it, I like to begin with the large shapes in the sky. Then, because the building is in the background behind the trees, block in the building. Establishing the basic colors of the building and the tree trunks early on allows you to lay foliage on top of them. If you're using a light touch you won't over-fill the tooth of the paper.

6 Start with the Darks

As a general rule when working in pastel, it's a good idea to lay in darks first. You can apply a light color over a dark successfully, but placing a dark color over a light one results in a lighter-value dark color or even a muddy color. So, once the background elements of sky and distant building are in place, select the darkest greens of the foliage and put them in place.

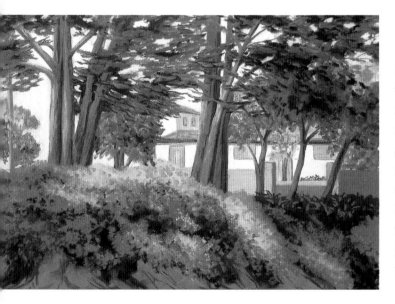

7 Refine the Shapes, Add Finishing Touches

Begin defining smaller shapes, paying attention to values and temperature. Areas that were blocked in as one large value mass may now be broken down into several closely-related values, as in the foliage. The warm sunlight colors and cool shadow colors of the underpainting give you a guide to the temperature of each area. Look for mistakes that might need to be corrected—for example, note the roof-line on the second story of the building and the added windows. Final touches include the deep blue-green shadows around the white flowers and the flowers themselves (which are painted a light blue-gray, not white). Red flowers in front of the building add interest.

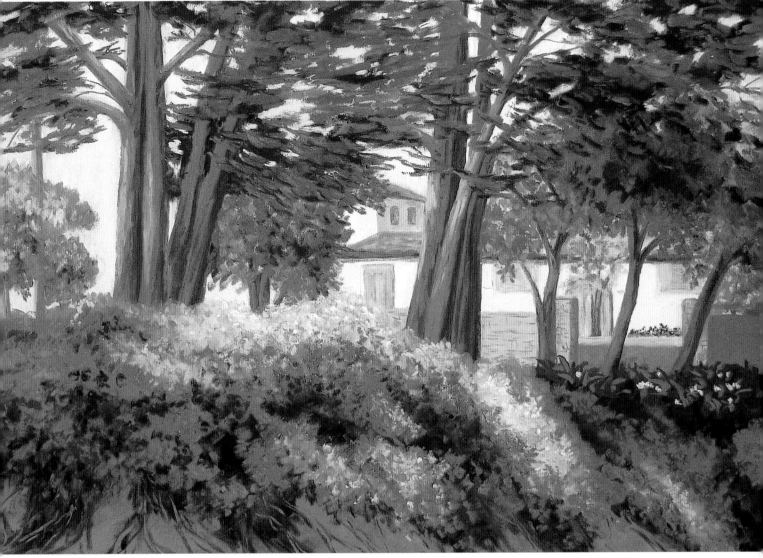

8 The Finished Painting

The finished painting retains a strong feeling of sunlight and shadow. The painting is simplified in comparison to the photo, resulting in a more painterly appearance while still retaining the mystery of the half-hidden house.

San Simeon Bluff
11" x 14" (28cm x 36cm)

mounting paper to a board

When you work on surfaces that allow liquids, an underpainting with a wet medium is a great way to start. We'll look at several underpainting methods in the next few pages, including underpainting with watercolor, gouache, oil stains, pastel and Turpenoid™, and pastel and water. But before you try one of these, make sure your surface can handle it.

If you have doubts about whether your surface will be damaged or warped by a wet medium, test it first. Turpenoid™ washes do not usually penetrate a surface such as Wallis sanded paper enough to warp or buckle it. But if you're going to use a water-based medium or an oil stain, it's a good idea to mount the paper to a board.

You can take your painting surface to a framer and have it dry-mounted to a backing board such as museum board, illustration board or acid-free mat board. But artist Greg Biolchini mounts Wallis Sanded Pastel Paper to a board himself, using an acrylic matte medium as a glue. Mounting the paper not only keeps it from buckling as you apply wet washes, it keeps it from becoming wavy under glass after it is framed.

This demonstration shows how to mount Wallis Sanded Pastel Paper to a four-ply museum board using Liquitex Matte Medium as glue. Acrylic matte medium dries fast and produces a more permanent bond than commercial dry-mounting.

materials list

Wallis Sanded Pastel Paper

Four-ply museum board, cut to the size you'd like

Brown kraft paper (cut slightly larger than the museum board)

Foamboard (also cut slightly larger than the museum board)

Liquitex Matte Medium

4-inch (10cm) house-painting brush

Container for the acrylic medium

Heavy books (to weigh down the paper as it dries)

1 Apply the Matte Medium to the Board

Squirt a generous amount of matte medium onto the board straight from the bottle. Don't skimp on the medium or it may not hold. Then, using a 4-inch (10cm) house-painting brush, brush it out into an even coat across the surface.

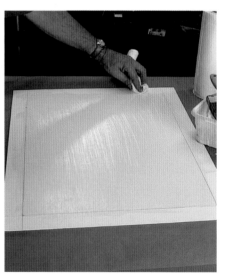

2 Remove Excess Medium

After covering the entire area where the paper is to be affixed with the matte medium, wipe off the excess medium from the brush onto the side of a plastic container. Then go back over the surface, crisscrossing each pass with the brush to lift off excess. If any medium has gotten onto the border area (the board that will show around the painting surface) wipe it off with a paper towel. Continue to brush over the matte medium until it begins to feel a little tacky as you drag the brush over it.

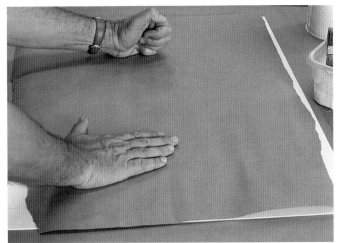

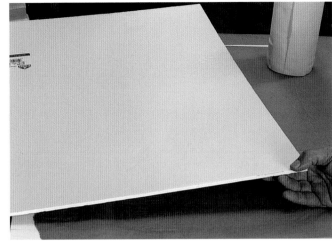

3 Press the Paper onto the Board

Cover the Wallis paper with the brown kraft paper, making sure the brown paper entirely covers the Wallis paper. Begin smoothing it out and pressing it down with your hands. The brown paper will protect your hands from the gritty surface of the Wallis paper. Continue pushing the paper down and rub or hold it until the glue dries, which should only take a couple of minutes. You may want to lift the brown wrapping paper occasionally during this process and check to see where it needs to be pressed down more.

4 Apply Some Weight

When you are satisfied that the Wallis paper is glued securely, leave the brown kraft paper in place and lay a sheet of foam board over it. Place heavy books or weights on top of it, distributing the weight evenly. Leave the weight on the mounted paper for at least an hour to ensure the bond.

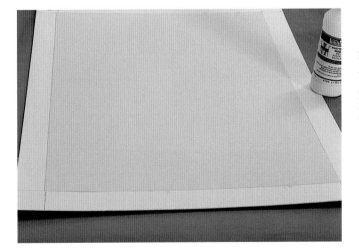

5 Coat the Back of the Board

The next step is to coat the entire reverse side of the museum board with a generous amount of the matte medium. This is a necessary step: It prevents the board from warping. Let this counter-priming dry with the museum board lying flat overnight.

mixing pastels with watercolor

Many artists who work in both watercolor and pastel have discovered that a failed watercolor painting can be rescued with an application of pastel. But you don't have to wait for a failure—you can take advantage of mixing these and other mediums with pastel deliberately.

A watercolor underpainting does not have to be entirely covered by an application of pastel. When combining the two mediums is the goal, allowing runs to happen—places where the water carries the paint to an unplanned spot—can be desirable and enhance the final painting. This demonstration subject is complex, so a careful drawing is important, as is the watercolor "road map" of initial colors and values. These will keep subsequent steps from going astray.

materials list

White Professional Grade Wallis Sanded Pastel Paper

Nos. 4, 8, and 10 round brushes

Color shaper nos. 2 and 6 flat

watercolor pencils

Copper beech, deep vermilion and lemon cadmium

watercolor paints

Cadmium Yellow, Yellow Ochre, Cadmium Orange, Cadmium Red, Alizarin Crimson, Hooker's Green, Cobalt Blue

pastels

light ultramarine blue, middle ultramarine blue, dark blue-purple, light yellow-green, dark yellow-green, middle value blue-green, middle value green, dark blue-green, dark red, middle-value purple, dark purple, middle value brown, dark brown, burnt sienna, middle-value blue-grey, dark blue-grey. middle-value purple-grey, dull grey-blue, red-gray, middle-dark blue grey, purple-gray, light orange, middle-value orange, bright orange, dark orange, red-orange, pink-orange, yellow, yellow-white

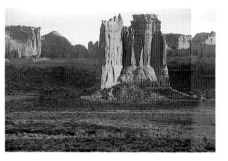

reference photo
The photograph used for this demonstration was taken at sunset at Arches National Park in Utah. Note the lighter strip at the right side of the photo—this is a second photo spliced onto the first to position the major formation of rocks farther away from the right-hand edge of the composition.

1 Make the Rough Sketch

Do the preliminary sketch in watercolor pencil on White Wallis Sanded Pastel Paper. The watercolor pencil will dissolve into the watercolor as the washes are applied, whereas a graphite pencil would show through. A few color notes are placed in some critical areas, but most of this stage is the drawing and positioning of the compositional elements. As this drawing developed, the foreground was simplified to eliminate one band of light.

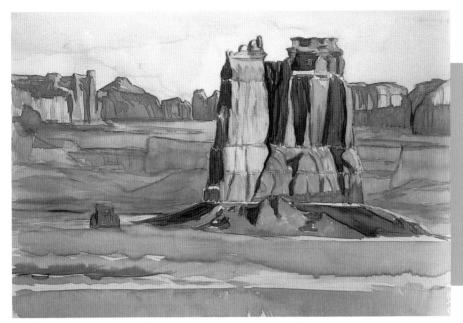

detail

A close-up look at the distant rocks shows the watercolor application and some overlapping of colors. If runs occur, they can be dabbed off with a paper towel, or allowed to remain if they do not create confusion. While the watercolor is still wet, mistakes can be lifted off with a brush or paper towel.

2 Create the Watercolor Underpainting

Apply the watercolor underpainting, paying careful attention to the colors and values of the rock formations. Because the grasses in the foreground and mid-ground are not complex drawing challenges, you can just merely suggest them in the underpainting.

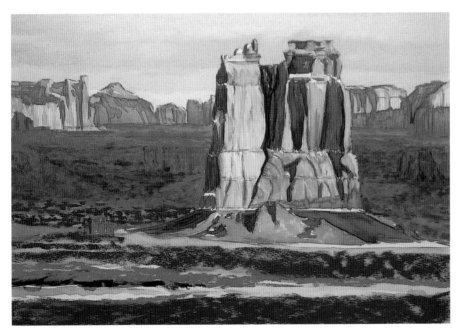

3 Develop the Sky and Foreground with Pastels

Because all the values in this painting relate to the color and value of the light and the color and value of the sky, it's a good idea to get the sky color laid in early. Two values of light Ultramarine Blue pastels are blended for the sky. It's also easier to outline the edges of the rock formation and other elements against the sky rather than trying to work the sky color in around them. Next, roughly indicate the mid-ground and foreground dark colors.

4 Add the Darkest Foreground Values

Apply the darkest values of the large foreground rock formation. In general these colors simply restate the pattern established by the watercolor in stronger and darker values. An assortment of pastels is used, including dark red, blue-purple, blue-gray and a dark brown.

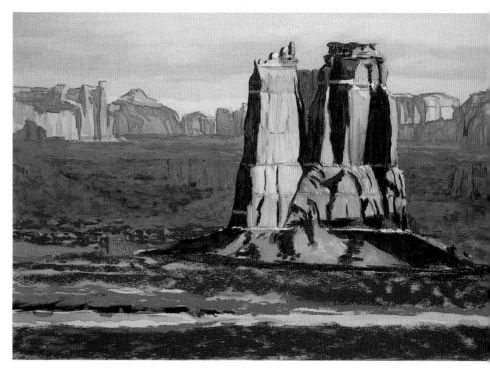

5 Paint the Distant Rocks

Paint the distant rocks, paying careful attention to the values of the watercolor underpainting. (I stepped back from the composition at this point, and it became apparent that the small rock formation left of the major towers in the foreground was a compositional problem. Small shapes tend to recede, while larger shapes come forward. Having a small shape in close proximity to the large one was confusing, so I covered it with foliage.) For the distant rocks, select an assortment of colors, including dark orange, burnt sienna, middle and light orange, yellow and blue gray.

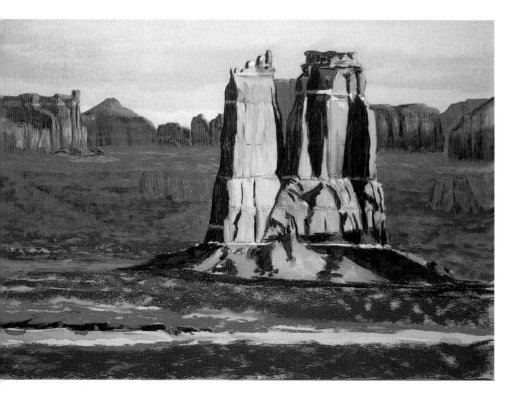

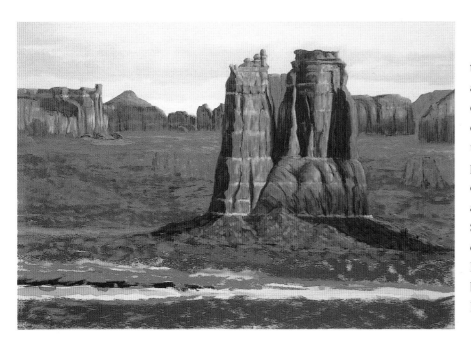

6 Develop the Details

Refine the foreground rock formation by strengthening value contrasts and tightening shapes, and further develop the mid-ground. Because the entire mid-ground is in shadow, its values must remain similar. This is a good place to use broken color—several colors of the same value intermixed in an area. Use the following colors: Burnt Sienna brown, dark, middle and light orange-yellow, red-orange, orange, yellow, yellow-white, bright orange, dark brown, blue-gray, purple-gray and yellow-green.

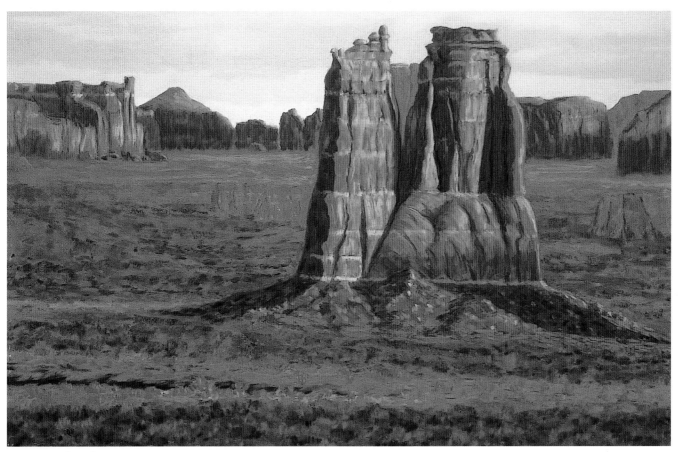

7 Complete the Painting

The last steps are completing the foreground and making small corrections and revisions to the entire painting as needed. Some edges have been softened with paint shapers and some sharpened with a new application of pastel. The pattern of the streak of light across the bottom foreground has been refined.

Last Light at Arches
13"x 19" (33cm × 48cm)

underpainting with gouache

Many things make gouache (opaque watercolor) an excellent under-painting medium for pastel. It dries to a matte finish, making it particularly compatible with pastel, which also has a matte finish. It produces an opaque cover with a thin coat, so you don't have to use so much gouache that you fill the tooth of the paper—it leaves plenty of room for layers of pastel. Also, gouache remains water-soluble even after it dries, allowing for easy changes in the early development of a painting.

materials list

White Professional Grade Wallis Sanded Pastel Paper

Nos. 12 and 16 round synthetic watercolor brushes

1 ½-inch flat synthetic watercolor washbrush

gouache opaque watercolors

Ivory black, Burnt Umber, Ultramarine Blue, Green, Red, Yellow, Permanent White

pastel pencils

middle-value gray/cool gray, black, middle-value and dark carmine red, middle-value purple, light gold-ochre, middle-value orange-yellow, middle-value viridian, middle-value orange, dark violet deep, dark caput mortuum, raw umber, burnt sienna

pastels

middle-value bright red, dark carmine red, middle-value scarlet red, middle-value warm pink, dark and light warm gray, middle-value cool gray, light cool gray, light dull pink, light dull orange, dark orange, middle-value chrome yellow, middle-value cadmium yellow deep, light pale yellow, black, dark burnt umber, middle-value Van Dyke brown, middle-value cocoa brown, burnt sienna, middle-value Titian brown, raw sienna, light yellow ochre, very light warm yellow, middle-value warm blue, light warm blue, white

1 Make the Initial Sketch
Use an extra-soft willow vine charcoal stick to draw in the biggest shapes of your subject. Use only as much detail as you need to position the biggest elements of the subject; remember that the sketch will be covered with the underpainting.

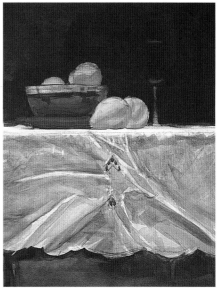

2 Apply the Gouache
Block in the large shapes of the painting with gouache, then the background using a no. 10 flat with Burnt Umber, Ultramarine Blue and a little black. Paint everything else, except for the lightest area (in this case, the tablecloth), with a no. 16 and no. 12 round watercolor synthetic sable brushes. Block in the large shadow area on the tablecloth with the no. 10 wash brush using a diluted mixture of Burnt Umber and Ultramarine Blue. Diluting the gouache with a little water allows you to use it like transparent watercolor. Indicate the wine glass by removing some of the pigment from the background with a small, stiff bristle brush.

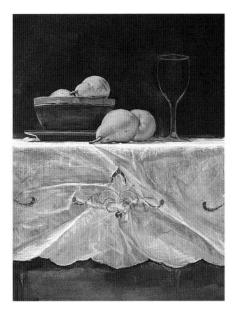

3 Re-draw with a Pastel Pencil

Because the initial drawing has been lost by the application of gouache, it's helpful to re-draw the subject with a pastel pencil at this stage. If any errors have been made in the gouache application they can be corrected now, and the edges can be refined and the subject clarified with the pastel pencil.

(In this case, the artist drew a line dividing the center of the wine glass in order to make it easier to draw it symmetrically. Then he decided the composition would be better if the wine glass was moved over to the right a little bit.)

4 Add the Pastel

To make the glass and the wine it contains look realistic, build up the values gradually from dark, to middle dark, to middle, to middle light, to light, and then to very light, always paying careful attention to the edges. It is the middle values that make the magic happen—highlights are important, but apply them only after you have put in all of the middle values.

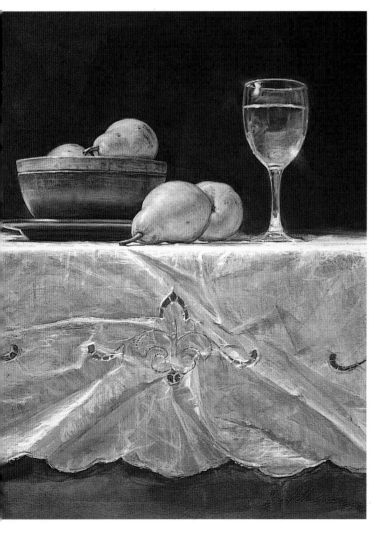

5 Place the Final Touches

As the painting neared completion, the artist felt some of the values in the shadow in front of the tablecloth were a little too bright. He dulled the values of the tablecloth by spraying it with Tuffilm pastel matte fixative spray. He did not spray the whole painting—if he had sprayed the pears or wine glass with fixative, it would have dulled and darkened them too much.

Step back and take a serious look at your painting, and see if there is anything you can put in or take out to improve it. Most adjustments in the final stages will be softening edges, putting in highlights and fine-tuning. At the end of a painting, more thought needs to go into each stroke; these final touches can make or break a design.

Pears with Pinot Grigio
22" × 18" (56cm × 46cm) by Greg Biolchini

using water in your underpainting

If you don't like the smell of even supposedly odorless Turpenoid™, try brushing or spraying your pastel with water for the underpainting and as you continue to work.

Unlike Turpenoid™, water does not "melt" the pastel but rather makes it a somewhat pasty blend. Use caution when spraying or brushing on water, and watch for lumps or paste-like areas. Those can be removed with a wet brush or scraped off with the side of a palette knife; if allowed to remain, they will prevent further pastel from adhering to the surface.

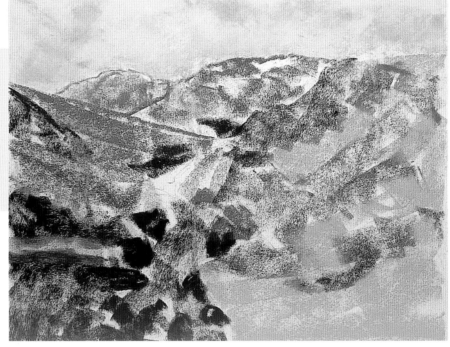

detail
This is a close-up of the sky area after spraying it with water. Note that the water lays on the surface more than Turpenoid™ does.

materials list

White Professional Grade Wallis Sanded Pastel Paper

Nos. 8 round brush

Spray bottle with distilled water

pastels

light pinky-lavender, middle-value lavender, light cool blue, dark cool blue, light blue-gray, middle-value blue-grey, middle value warm gray, dark blue-gray, light yellow green, middle-value yellow-green, middle value sage green, middle-value ashy green, middle value green, dark green, very dark greenish black, dark ashy green, dark blue green, light pink-white, light pink, middle value pink, middle value magenta, dark purple, dark magenta, light yellow ochre, middle value yellow, light pink-orange, middle-value pink-orange, dark burnt siena, dark brown, pure white

1 Apply the First Layer of Pastel and Spray It with Water

Working on white Wallis Sanded Paper mounted to a board, apply the first layer of pastel and spray it with water. This is a rough block-in of colors, similar to those done in the early stages of other underpainting techniques, but keep the application of pastel light. Let some paper show through instead of covering all the white. Once the sky colors are blocked in, move quickly from dark to light values, keeping the shapes of color large.

Spray the surface lightly with distilled or purified water (chlorine in tap water may affect colors). Using an old or inexpensive brush (sandpaper will damage a good brush), lightly brush the colors together. After the pastel and water dry, add the next layer of color. Work from dark to light, breaking big shapes and masses of color down into smaller shapes and masses.

reference photo
The reference photo for this painting is of a hillside on the Isle of Skye in Scotland. It was taken on a cloudy day, but the photograph shows not even a hint of the clouds I remember. Photographs often do not accurately depict detail and color in the sky.

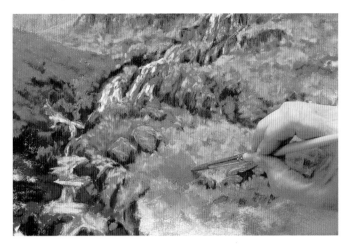

2 Develop the Painting

After you've added more color and created smaller shapes, you may want to use water again to help blend colors of similar values to create the impression of foliage. Here, a small area has been carefully sprayed and the brush is being used to bring the masses of color together. This technique could also be used to correct an area where you've made a mistake or changed your mind.

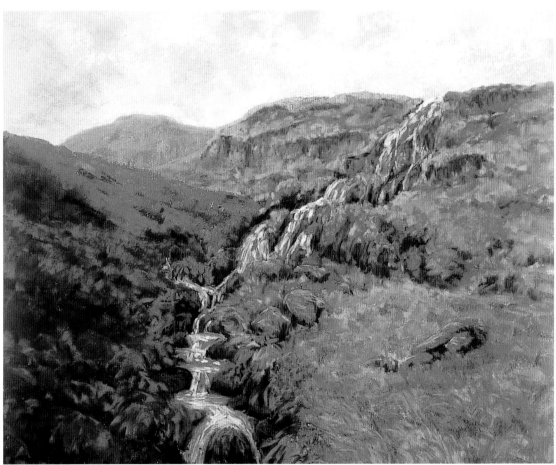

3 Finish the Painting

The finishing touches include creating the feeling of grasses in the foreground. On the left, this was done by holding small pieces of pastels in various greens and browns on their sides, making short quick vertical strokes with the entire side of the pastel. On the right, finishing touches of grasses were added with yellow ochre and green pastels, which layer nicely over the softer pastels underneath. Dark edges of the foreground rocks were created with very dark pastels, and their highlights applied with purple and magenta. Finally, the pink and yellow flowers were added with soft pastels.

Skye Morning
11" × 14" (28cm × 36cm)

using acetone for quick drying

Artist Bill Hosner works from life, whether outdoors in nature or inside with a model. He uses Wallis Sanded Pastel Paper and likes to begin with a pastel underpainting, which he sprays with acetone. Acetone dries quickly and lets him move on to the next application of pastel almost immediately. (If it smells familiar, it's because it's the same liquid as fingernail polish remover, only it's less expensive when purchased in quantity at the hardware store. Acetone sold as nail polish remover may have perfumes, oils or other additives that could be problematic if used on a pastel painting, so don't just head to the medicine cabinet.)

BEFORE

toning with acetone

After blocking in the big simple shapes of the subject, use a brush to wash it in with acetone, allowing some of the colors to blend if you wish. Note that while the shapes are simple, the values are already clearly established.

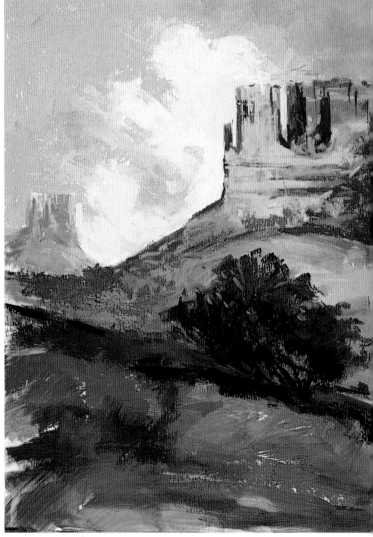

AFTER

finish the painting

As the painting progresses, you can allow some of the underpainting to show through here and there. The underpainting gives you a structure to follow for the completion of the painting, but you can still make changes as needed. Note the addition of small shapes of bushes on the distant hillside at the left, which were not represented in the block-in stage.

Red Sedona
11" × 14" (28cm × 36cm) by Bill Hosner

underpainting with an oil stain

Richard McKinley likes to begin his pastel paintings with oil stain underpaintings. He applies the oil stain either to a surface coated with gesso, acrylic and pumice, or to Wallis Sanded Pastel Paper (raw paper would deteriorate quickly with this application). To avoid filling the tooth of his surface, he generously thins the oil paint with odorless mineral spirits. The goal is to create an oil stain or wash, not an oil painting.

The surface should be allowed to dry before you add pastel; either place it in direct sunlight for a little while or let it dry overnight.

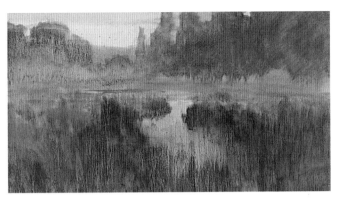

start by staining
An oil paint stain on a gesso/pumice prepared surface.

you don't always need an underpainting

While underpaintings are one way to begin a pastel painting, they are not a requirement. You can pick up a piece of paper and begin immediately with pastel. How do you know when to underpaint and when not to? There are no absolute rules, but in general an underpainting is not a good idea if you're working on a surface with very little tooth, such as Canson paper. On surfaces with little tooth, you'll need to limit the number of layers you apply; most untreated surfaces cannot be washed with a liquid.

If you're working on a surface that already has a color, such as Art Spectrum's Colourfix, you may not want to apply an underpainting. You've selected that color because it will complement or harmonize with the colors you're going to apply to it, so an underpainting isn't necessary.

Experiment with underpaintings when you're working on a surface that can take a number of layers, and see if you like any of these methods. Remember that not all methods work for every artist, and that the only right way to paint is the way that works for you.

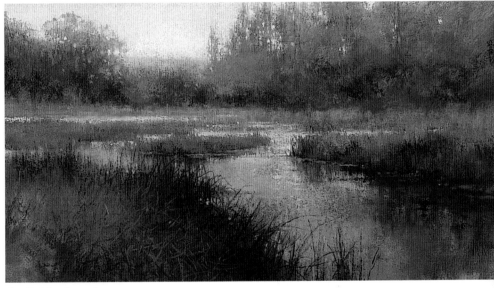

the finished product
The basic color pattern is established with the oil stain, setting the tone and mood for the layers of pastel to follow. Note how some colors are modified to lighter values, such as the sky and the hint of the setting sun, while others are darkened slightly, such as in the foreground water.

My Evening Place
13" × 24" (33cm × 61cm) by Richard McKinley

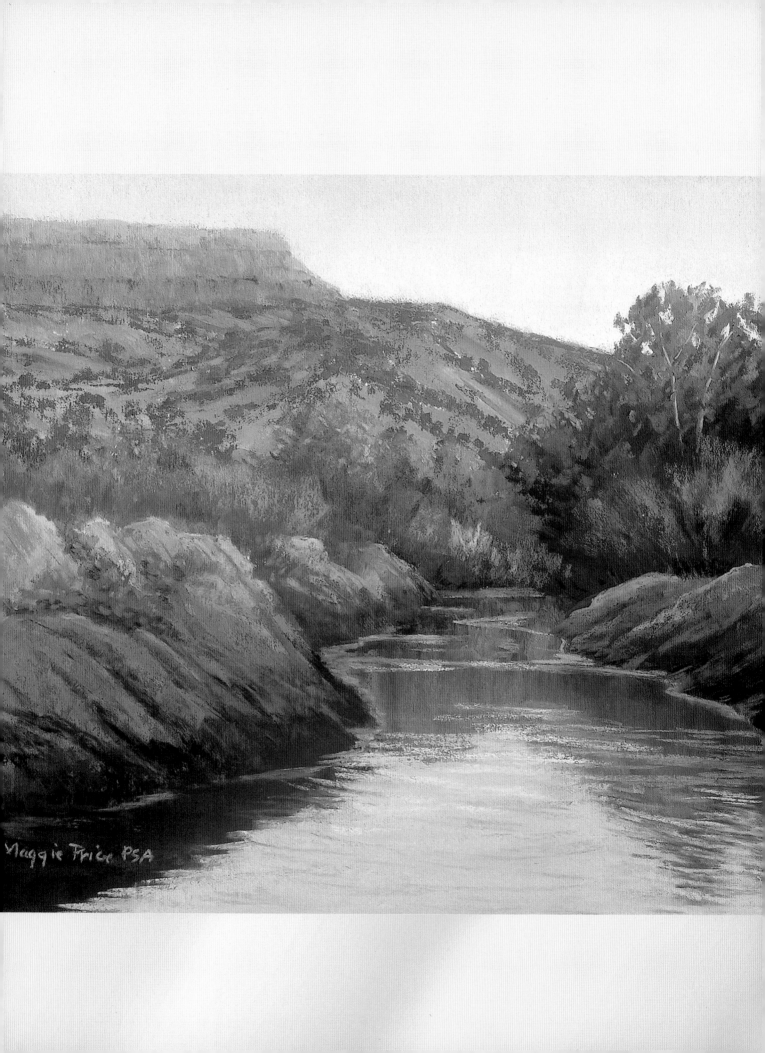

Maggie Price PSA

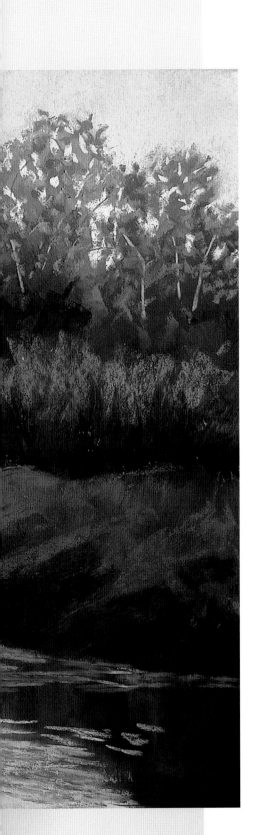

painting from photographs

Most artists paint from photographs, and it's a great way to get started learning the basics of using pastel. However, there are a few things to keep in mind when you work from photos. The most important thing to remember is that you are making a painting, not just enlarging a photograph, and you can—and should—make changes to improve the composition, color and size of the image.

Water Crossing
11" × 17" (28cm × 43cm)

photographic inconsistencies

Cameras don't record images in the same way that the human eye sees them. And unless you're an expert photographer with professional equipment, you're probably using an ordinary camera for reference photos. When you point the camera at a scene, it takes a reading of the available light, usually measuring it at the center of the image area. All the other light and dark areas in the scene are affected by this light reading. So if the center of the image is in a dark area, then light values in other areas will probably be too light in the resulting photograph; if the center of the image is lighter, other values will probably be too dark.

Common examples of this occur in photographs that focus on light areas of foliage or sunlit water. Everything else in the photo will usually appear too dark in value. But if you focused the camera on the dark foliage instead, then the light values might appear nearly white.

photo flaws
This photograph shows several flaws of the camera. The blue sky has washed out to nearly white near the horizon, while the ground and particularly the trees appear too dark.

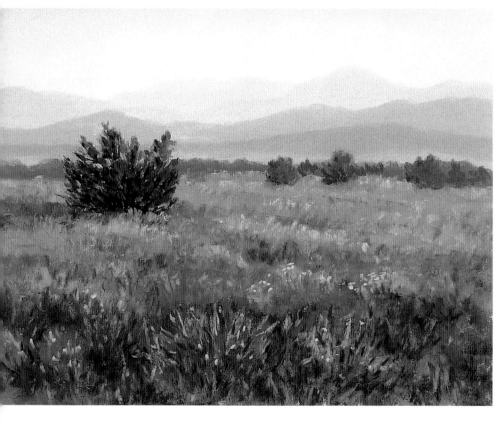

faded skies

A common problem in ordinary photography is a sky that's faded too white or pale blue. When you're looking at your photograph but don't recall the atmosphere at the time you took it, an easy way to tell if the photo is accurate is to look for cast shadows. If there are strong cast shadows and a feeling of sunlight, but the sky appears white, then you can safely assume the sky was in fact blue and the photograph is inaccurate.

Occasionally photos will show a sky that is significantly darker blue than it should be, usually as a result of the light reading being focused on an area of lighter values than the sky. In this case, as in the previous case, analyzing values in the rest of the photograph will help you determine whether the sky color or its value is accurate.

In this painting, the sky has been adjusted to a more accurate value and the colors of the foliage lightened to more realistic values.

Turquoise Trail
8" × 11" (20cm × 28cm)

don't paint all the details

When you look at a scene and focus, for example, on a tree in a field, you see the tree in sharp detail. However, while your eyes are focused on the tree, they perceive much less detail in other areas of the scene through your peripheral vision. Cameras, unlike your vision, record all detail evenly in the photograph. If you copy the photograph as you see it, it may look more like a photograph than a painting. Keeping the details minimized in areas other than the focal point helps lead the viewer's eye to the focal point. The viewer will also perceive the painting more as he or she would see the scene in reality, lending a sense of believability to your artwork.

too much detail steals the focus
In this photograph, there are too many details visible in the distance, which would bring it forward and make it appear too close to the viewer if it was painted with the same detail. Too much clutter on the hillside takes the attention away from the breaking wave.

shoot with a painting in mind

Your camera can be your first compositional tool. Experiment with framing the scene in different ways—horizontal and vertical formats, zooming in and back out. Think about why you like the scene and what the most important element in it is as you take the photo. Make notes if you can; if that's not possible, observe carefully and make mental notes. Having your painting goals in mind as you take photos will benefit your future paintings—and make you a better photographer!

The compositional decisions you make as you take photos are one reason it's best to paint from your own photographs. If you use another person's photos, then you've started with someone else's composition—and in some cases, it can also be a copyright violation.

As an artist, you'll continue to hone your visual memory for color and value, and with practice, you'll find your memory of the actual scenes will return when you look at your photographs.

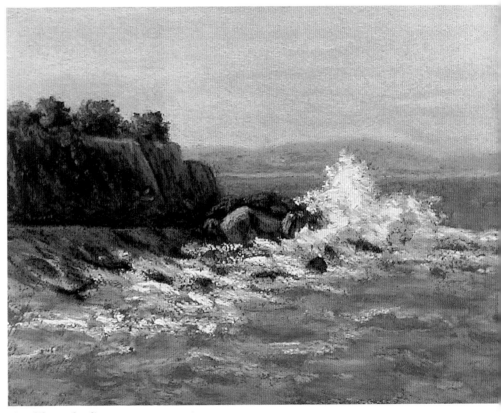

simplify and adjust
Moving the wave to a more interesting position and minimizing details in other areas puts the focus on the breaking wave. The cliffs on the left are simplified, leaving out the small shapes of foliage and massing them together, and many of the rocks have been eliminated.

Cornish Coast
5" × 7" (13cm × 18cm)

cropping your photos to create drama

When you take a photograph, you've got a specific image in mind that you want to record. But the camera may record a wider field of vision than just your point of interest. Later, when you look at the photograph, you may be tempted to paint the entire scene. Before you do that, experiment with cropping the photo. Ask yourself what it was that you were most interested in when you took the photo, and then try cropping in on the subject to find the best composition.

the original photo
This photograph shows far more than the rock formation, which was the subject I had in mind when I took the photo.

first crop
Cropping makes a more interesting composition, but there's still more foreground than necessary.

cropping further In
Another crop takes the composition down to the main point of interest. Note how the rock formation feels more massive and impressive when seen up close than it did from far away, and how the cast shadow becomes an important element in the composition.

final crop
With the final crop, the light on the bluff becomes the most interesting thing about this photograph—my original intent.

paint the scene
Cropping the photo led to a painting primarily of the bluff, with the trees as lesser points of interest. The beautiful colors of the rocky bluff draw the eye, so leaving in those elements cropped from the photo only would have made the scene overly complicated and busy, detracting from the focus.

Arkansas Bluff
11" × 17" (28cm × 43cm)

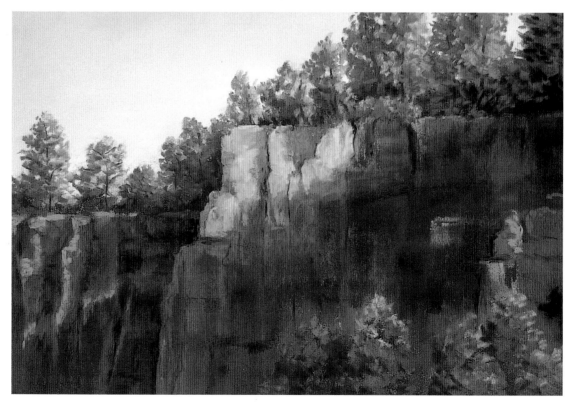

make the painting better than the photo

Analyze your reference photograph for what you like and don't like and consider changes to emphasize the idea behind the painting. In some cases you may combine more than one photo, or even rely on memory or imagination to make up a new portion of the photo. Don't be afraid to experiment—the goal is to make a painting that's better than the photo.

distracting foreground
What's interesting about this photograph is the leaning tree and the little waterfall. But the mass of rocks in the foreground detracts from the center of interest.

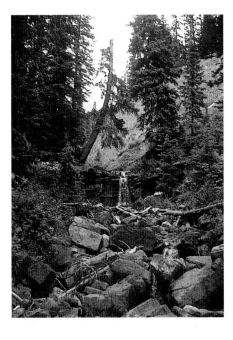

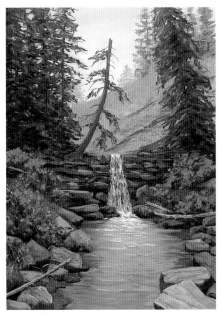

rework the composition
The solution to the foreground problem? Eliminate it and paint an inviting pool of water from memory. You could also use another photo as reference if you don't have a strong memory of streams you've painted previously. Be sure to pay attention to details such as the hint of reflected greens in the water on the right.

Mountain Waterfall
14" × 11" (36cm × 28cm)

evening photos

Sunsets and evening light are attractive subjects but difficult to paint on the spot because they are so fleeting. Relying on photographs presents problems, however, because land masses are generally too dark. Because you're focusing the camera on the brilliantly lit sky, the foreground will appear black or nearly black in the photo, even if the values were lighter in reality. One solution is to take two photos, one focusing on the sky and the other on the land mass, and then combine them.

Another solution is to lighten those values and then paint shadow areas with interesting color. Using broken color in the shadows is very effective, as is the careful use of reflected light.

dark land mass
This dramatic sky is an inviting subject, but the foreground is significantly darker in the photo than it would appear if you were standing at the site.

deleting and imagining
Cropping unnecessary elements and bringing some interesting colors into the shadows dramatically improve the subject. The road in the original photo would not have added interest to the scene, and, in fact, the strong diagonal took the viewer's eye out of the photo. Items like telephone poles and signs are best omitted unless they add a strong design element or interest to the composition.

Sandia Sunset
11" × 17" (28cm × 43cm)

working from two photos

Choosing a photograph to paint is an intuitive process. Choose photos that invoke a strong positive response. Then, go through them again and ask yourself what you like about each. Make your choice based on the strongest response.

You may have elements from two photos that you'd like to combine. If the photos were shot at the same time and from about the same distance, it's an easy task. But be wary of combining photos from different places, or photos taken at different times of day or with different lighting conditions. You don't want the sunlight coming from different directions in the same painting!

materials list

White Professional Grade Wallis Sanded Pastel Paper

Extra-soft vine charcoal

Pastels

very light cool blue, medium-light cool blue, middle-value cool blue, middle value blue, dark blue, very dark blue, light lavender, middle-value purple-blue, middle-dark purple-gray, dark purple-blue, light blue-green, middle-value blue green, dark blue-green, light yellow-green, middle value yellow-green, dark yellow-green, light yellow, middle-value yellow, yellow ochre, middle-light value green, middle-value green, dark green, dark greenish-black, light beige, light brown, middle brown, dark brown, middle-value reddish-brown, dark reddish brown, very blight blue-gray, light blue-gray, dark blue-gray, pure white

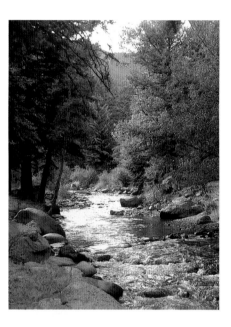

**reference
photo #1**
This photo is a good choice for a painting because it includes both the mountain and the foreground water. The focal point will be the water, but including the distant mountain will give the piece a sense of depth.

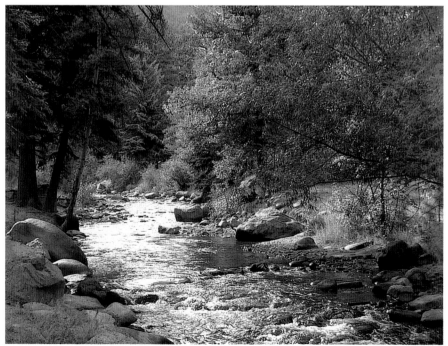

**reference
photo #2**
The horizontal shot gives more reference to the land on the right side. Combining the two photos will make a better painting.

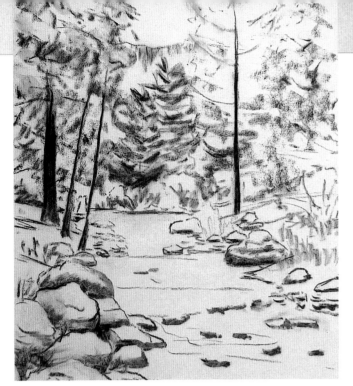

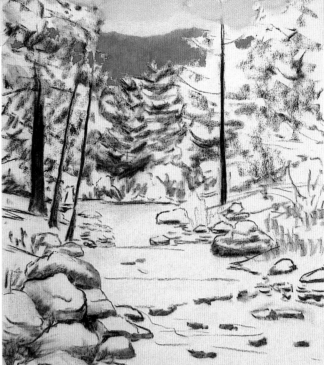

1 Draw the Scene

A careful drawing is important when combining photos. Extra-soft vine charcoal on white Wallis Sanded Paper allows for revisions with a kneaded eraser as you work. The areas where the charcoal is heaviest will be the dark areas in your painting. When the drawing is done, blow on it lightly to remove excess charcoal.

2 Work from the Background Forward

As you paint the sky, note the inaccuracy of its color and value in the photograph. Begin with the most distant areas and work forward to keep your unpainted areas clean. Remember, tilting your easel forward a little will allow dust to fall onto the easel tray rather than accumulate on unworked areas of the painting.

Paint the largest "sky-holes" in the foliage of the trees. The distant mountain will show through the foliage also, so paint the largest areas where it might show. It's easier to paint the mountain now, before beginning the foliage of the trees in front of it.

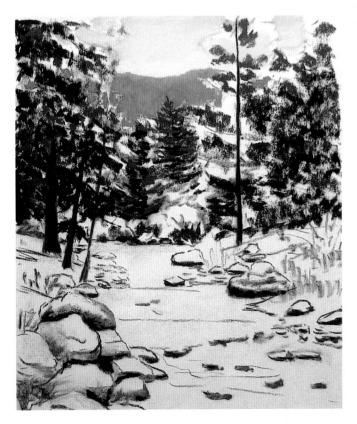

3 Begin the Foliage

Moving forward from the mountains to the mass of trees, paint the darkest darks first. Only the largest tree trunks need to be included at this stage—don't worry about branches. Squint at your photo and try to see the foliage as shapes of dark green, dark green-blue, dark brown, and even some purples and reddish browns. Use all these colors in the foliage as you see them, trying to paint shapes of color instead of leaves. When you paint foliage, place masses of color, thinking of the shapes of the color mass rather than leaves or needles on a tree.

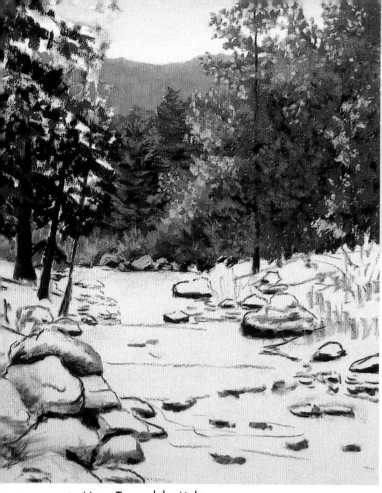

detail
Remember that foliage is darker where it's massed together heavily and becomes lighter in value—and the shapes get smaller—toward the outer edges of the tree. While it's still not necessary to paint leaves, lacy edges will give the impression of leaves.

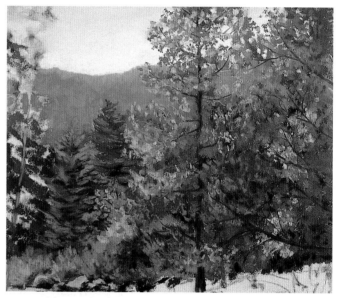

4 Move Toward the Light

Once you have all the darkest foliage values in place, begin moving toward middle values and then light values of assorted greens, yellow-greens and yellows. The lightest values should be the last ones placed—if you put them in too soon and then decide you need to darken them, the colors can become muddy. Remember, with pastels you can always put a light value over a darker one.

Establish the distant river bank, blocking in the rocks as you work the distant foliage. Putting those in place now will allow you to put the water in front of them later.

5 Add Some Foliage

After you place the branches, go back with the leaf colors and pull some foliage across them here and there so they don't look pasted on. Cross the tree trunks here and there with foliage as well.

keep your colors handy

Set aside the colors you used for the sky and mountains. You'll need those later to use in other areas where you decide to let sky or mountains show through the foliage. The pastels shown here are the sky colors, a very light blue, a light blue-green, and a medium-light Ultramarine Blue. The colors used on the distant mountain include a medium value blue-gray, a medium value blue-green, and a medium value blue.

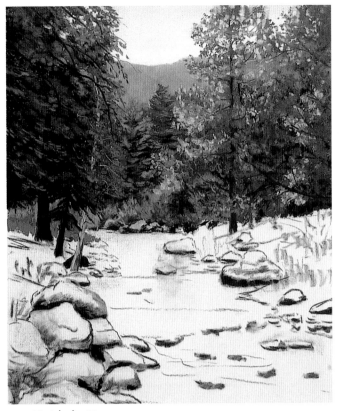

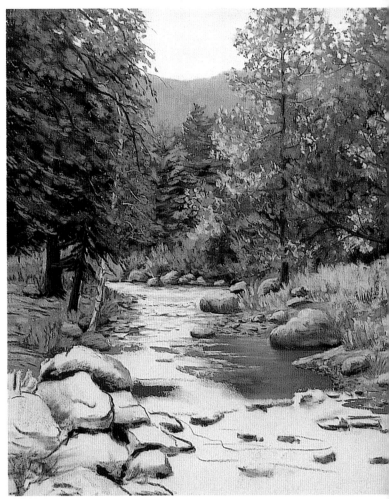

6 Finish the Trees

Putting the branches in last is easier than drawing branches and then trying to connect masses of foliage to them. Remember, you're not copying the photo exactly, but rather creating an impression of this type of tree. Draw in a few branches, but not as many as you see in the photo. Notice that the branches are darker in value and color the closer they are to the tree, and lighter as they move away from it. Look for a place where you can draw a branch across a sky hole—it helps keep the sky distant.

Move to the rest of the foliage in the mid-ground and proceed with the middle and, finally, the light values of greens and yellow-greens. Add sky holes or holes where the mountain shows through as needed to keep the trees looking airy. The trees on the left are mostly darker in value than the ones on the right, so fewer of the lightest greens are needed there. Because there are a lot of shadows in this mass of foliage, look for places you can add some blue or blue-green.

7 Begin the Water

Distant water will generally be lighter in value than water closer to the foreground, since it reflects the sky at the horizon, which is lighter in value than the sky directly overhead. Keeping that value structure clear will enhance the impression that the water moves away from the viewer. Painting the rocks at the same time as the water, as you move forward in the painting, will help preserve clean edges.

To depict a fast-moving stream, it's not necessary to paint the ripples of distant water; in fact, doing so will make the water appear closer. Keeping the distant water simple keeps it in the background. Paint the reflecting greens before placing ripples over them. Once the area is covered with the greens and yellow-greens of the reflection, blend gently with your fingertips, using a horizontal stroke to flatten the water.

8 Add Water Rivulets

Paint the rocks that the water will tumble over before painting the water. Then you can indicate shallow rivulets of water coming over the rocks with just a light skim of watercolor.

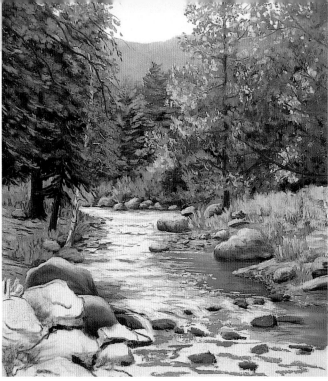

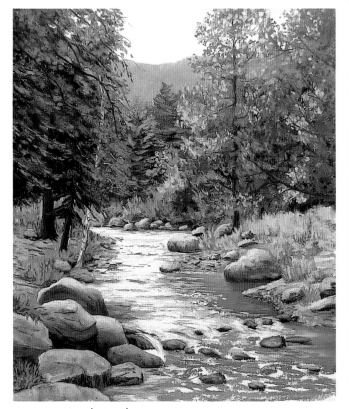

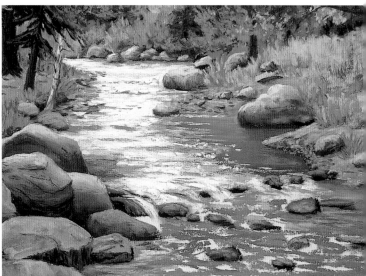

9 Painting the Rushing Water

When you look at a photo of rushing water, there appears to be a lot of white. However, that's usually an effect of the lightening of light values created by photography. If you carefully observe rapidly moving water, you will see there is very little white, if any. Paint the darker values of the water with grays, blue-grays and green-grays, then move to paler blues and grays. The highlights of the rushing water can be created with pale pinks and yellows. No white pastel should be used at this stage.

The direction of your strokes will help create the impression of movement in the water. As the water tumbles over the rocks, indicate its downward movement with downward strokes. Paint splashes in upward and sideways directions.

10 Paint the Rocks

As you move forward, continue to paint the rocks while working on the water. Rounded river rocks can be a problem: You don't want them to look like potatoes! Create edges here and there, some indication of roughness to create interesting shapes. Where several rocks are piled together, emphasize different colors to keep them separate. Rocks aren't just gray or brown! Try purples, oranges, blues and greens, using the same values of several colors in an area.

Don't forget that the edges of rocks sitting in water are wet, and are therefore darker in value at the water line. Rocks that are splashed with water tend to have blue in their darker values. As you move to the immediate foreground, block in the foreground water, which will be darker in value than the mid-ground water.

11 Place the Finishing Touches

Step back and analyze the painting as a whole to see if any shapes or values need to be tweaked. Be careful to make only those changes that will improve the painting: Don't overwork it!

Final touches include sharpening some edges and softening others, and blending the rushing water slightly with a light blue pastel. After painting the water, selected highlights can be enhanced with a very light blue-gray and a few touches of a pure white pastel in the splashing water. Tape a piece of paper to the board and lightly rest your hand on the paper while you make a revision.

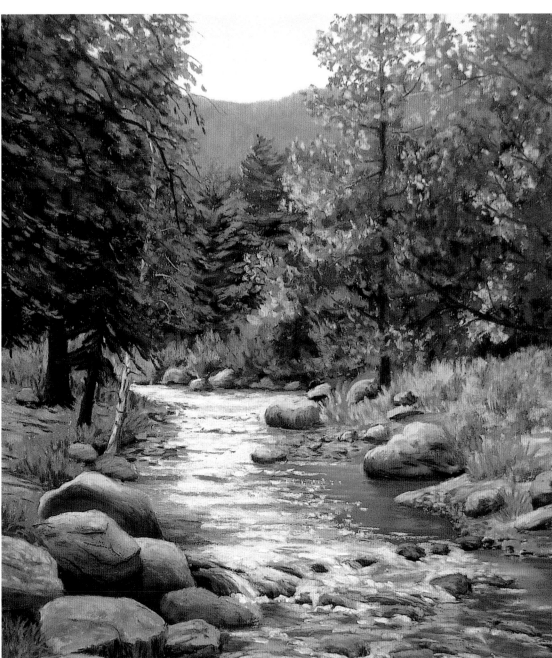

12 Finish the Painting

The finished painting incorporates elements from both of the original photos, eliminating unnecessary detail and simplifying shapes to improve the composition. In spite of the changes made, it retains a strong feeling of the place.

September on the Fall River
11" × 14" (28cm × 36cm)

painting from slides

Painting from a slide gives you the advantage of seeing the light in the landscape more clearly than in a printed photograph. Internal slide projectors are commercially available, and they look something like television screens. The image is projected onto the screen, and you get the advantage of light behind the subject. These projectors (even used ones) are generally quite expensive, though, and are not always easy to find.

Making Your Own Projector

Like most realist painters of today, artist Greg Biolchini depends on photography for a great deal of his subject matter. He decided early on in his painting career that working from slides would be superior to working from prints. Aside from the fact that slides are truer in color and more luminous than prints, they are far less expensive to process. In addition, a slide transparency can be projected onto a screen and blown up, forward or backward, up to almost any size and for no additional cost.

For some years, Biolchini favored a small rear-screen slide projector. But when it wore out, he discovered that no one made that particular projection system anymore. His solution was to build his own projection booth.

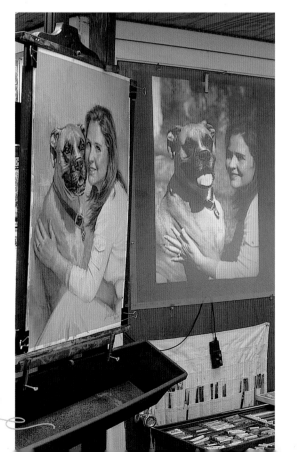

The Process

To build this projection booth, first cut a square 17" × 17" (43cm × 43cm) hole in the front of a long, heavy-duty cardboard box, such as a shipping box for a refrigerator. Then tape a sheet of matte Mylar (the strong polyester film used in bulletproof vests) over the hole, with the shiny side of the Mylar facing in and the matte side facing out. (You can purchase Mylar from a drafting supply store.)

Next, cut an opening in the back of the cardboard box big enough for an ordinary slide projector to fit into. Mount the box along one side to a wall in your workspace, so the center of the screen in the front end of the box is exactly on your eye level when painting. Elevate the projector in the box so the projected image is in the center of the Mylar screen. Leave the flap door in the back of the box open slightly while in use to prevent the projector from overheating.

Almost any projector will work with this system. For convenient slide changing and focusing, Biolchini recommends a projector with a remote control. This remote control will allow you to focus and change your slides from outside of the box.

Using Your Projector

If the projected image on the front of the screen is too light and weak, you're probably getting too much outside light on the front of the projection screen. The way to remedy this problem is to fasten some sort of hood over the top and down the sides of the front of the box. If this hood doesn't block the direct light and alleviate the problem, put blackout shades on the windows in your workspace.

If you plan to work from one slide for a week or longer, have a duplicate slide made. This is important because the heat from the projector will slowly fade the color from the slide, especially the blues. Do the majority of the painting from the duplicate slide, then finish it working from the fresh original slide.

a projector in action
The rear-screen projection booth in Greg Biolchini's studio was built on the principle described, only larger and more permanent.

painting live subjects

Many artists who paint portraits do so from life, or from a combination of working from a live model and from photographs. But some subjects are difficult, if not impossible, to paint from life. Among those are animals, who hold still only if asleep and then not reliably, and small children, who may not hold still under any circumstances.

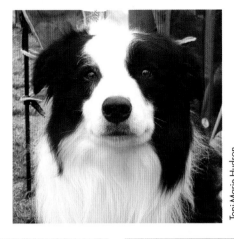

reference photo
Artist Deborah Christensen Secor loves to paint animals, and this photograph of "Buzz" is a great subject.

Toni-Marie Hudson

materials list

White Museum Grade Wallis Sanded Pastel Paper

3-inch wide foam hardware store house-painting brush

Extra soft thin vine charcoal

No. 6 flat chisel and No. 1 wide flat paint shapers

pastel pencils

Cretacolor Pastel pencil, light gray

pastels

middle-value green-gray, dark navy blue, dark teal-blue, medium teal-blue, dark grey-blue, dark red-violet, middle-value navy blue, dark violet, middle-value red-violet, black, dark purple, bright cobalt blue, light violet, light turquoise-blue, middle-value yellow-orange, middle-value magenta, reddish-brown, pale yellow, light yellow-ochre, pale yellow-green, pale blue-violet, white

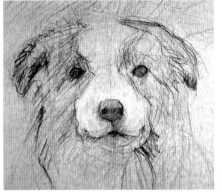

1 Draw Your Subject

Tone white Wallis Sanded Pastel Paper by lightly covering it with green-gray pastel, then rub it in with a foam brush for a medium-light value of a cool neutral color. Use extra soft thin vine charcoal for the underdrawing, lightly sketching the placement on the page. The subject is positioned to leave some "looking room" for the animal, which allows the viewer to sense movement. If the dog was right in the middle of the page, it would be static.

It's helpful to draw a line through the center of the pupils; note the angle, making sure that a line along the top of the nostrils is at the same angle. An animal's face doesn't flex this way, so line up the eyes, nose, mouth and chin if they all show.

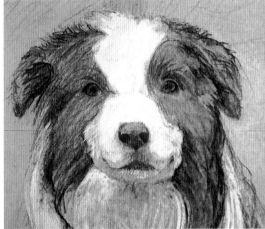

2 Develop and Refine the Drawing

Develop the drawing by refining the values and detailing the shapes. Pay attention to the three-dimensional shapes that make up the head, modeling it with the charcoal. This is the best time for corrections, because you can easily erase the charcoal with a foam brush and redraw. Find the shadows cast by the muzzle, under the ears or brows. Describe the fur with directional strokes, looking for key places where the color of the fur changes. Notice how much darker the value is in shadow, and depict the fur's texture. Use shorter strokes on the face and muzzle, lengthening them where the hair is longer.

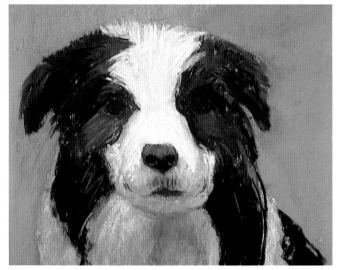

3 Paint the Background

Work the background right along with the portrait so it doesn't look as though the dog is superimposed on top of it. Remember that the dog's edges will overlap the background, so keep the layer of pastel near the dog from filling the tooth of the paper. Electric blue is a good background color choice for an active, mischievous-looking dog like this one.

4 Add Color to the Subject

Don't worry about putting down completely accurate colors first. More interesting colors can be used on what at first glance appears to be black fur—look for blues, purples and other colors to add interest. Start with colors you see underneath, in this case the blues and reds in the black and white coat. Unexpected colors such as lavender, green, peach, blue and yellow can be used to create the modeling of the nose, mouth and chin. Find the correct values of the colors and use more than one to make your painting varied and interesting. You'll layer more color to make the dog look more realistic later.

5 Begin Refining the Colors

Add more color, but still without using many details. Keep checking the alignment of the angles, measuring where the mouth lines up with the outside of the eye, for example, or how high the left ear is compared to the right one. Further model the forms using colors of the same value: medium-dark red-violet, purple and red in the black fur in sunlight; very dark purple, blue and black in the shadows of the dark fur; pale pinks, greens and yellows in the sunlit white fur; and medium turquoise, lavender and ochre in the shaded white fur. You can use a blending tool like a paint shaper to move the pigment around and begin to create the texture of the fur.

6 Paint the Eyes

At this stage, you may want to begin to paint the eyes, though some artists prefer to wait until the very end to add such details—if they become smudged, they'll have to be repainted. At this point, just make sure you have the correct value of the eyes and their underlying color laid in.

7 Develop the Impression of Fur

Now a few details can be created, such as the loose fluff along the top of the head and straggly wisps of fur where the black and white overlaps. The direction of your strokes is important, as is the length—short, quick strokes will give the impression of shorter fur, while long, thin strokes will work for longer hair. Use softer pastels to create the soft fur beneath an ear, and a harder pastel, or pastel pencils, for crisp details that create the impression of coarser areas of the coat. Create the drape of longer hair by using long, fluid overlapping lines, or make softly curling strands to enhance the effect.

8 Continue Forming the Face

Merge the shadow under the chin into a warm gray with touches of blue, and form the short hair along the upper lip with blue and gray dabs, making sure that bits of the lavender and pink can still be seen. Cool the red of the nostrils with blue to give them a damp look.

9 Define the Edges of the Fur

The edges of the fur are important—use quick, short strokes to indicate the way it stands up along the top of the head. Use the predominant color over the top, allowing your strokes to stand atop the underlying color with authority. Don't mix the pastel too much with too many strokes or your edges will look muddy.

10 Develop the Eyes

Make the eyes with simple, layered strokes, with the last strokes being the lightest colors. Reflect the blue of the background in them. It's best to define the eyeball using at least two colors. For instance, this dog has reddish brown eyes, but in shadow they're warm rust and they're golden brown in lighter areas. The eyeball is semi-transparent and round in shape, so define the ball of the eye with shape and values as well as color. The catchlight, or highlight, can be quite light in color, usually reflecting the ambient light around the animal. Paint this using one or two very light colors, such as pale blue and pure white. An elongated, curved catchlight further describes the form of the eyeball. Be sure to locate the catchlight in the same quadrant of each eye so that both eyeballs appear to be turned in the same direction.

Note that the eyelid is a different color on the top edge than the bottom. Look for the shadow cast by the upper eyelid along the ball of the eye, curving it to describe the roundness, as well as the lower portion of the eyeball that is slightly darker in color. The pinkish color of the inner skin and eye tissues makes the animal look alive. The pupil is very dark in color and is necessary to make the eye look complete even if the photograph doesn't show it.

The warm reds and pinks below the eyes bring more life to the dark fur and depict the light falling on the face, while cool black is used beneath the brow to show its form. A touch of pale yellow in the outside corner reveals the edge of the very large iris of the dog's eye.

11 Add the Whiskers

After the eyes are painted, touch up the white fur around the eye areas and add the whiskers. You can do this with the edges of soft pastels as shown here, or you may want to use a well-sharpened hard pastel or a pastel pencil for these final touches.

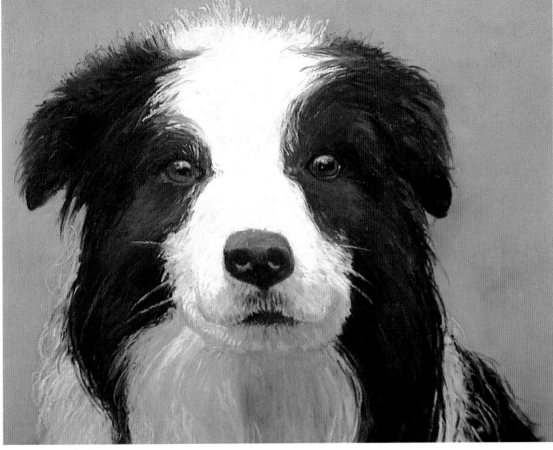

12 Finish the Painting

After looking at the painting for a period of time, carefully analyzing the details, add a few last touches; clean up some stray marks along the white of the face and smooth out several raw strokes over the right eye by the ear, and the portrait is complete.

Buzz
8" × 11 " (20cm × 28cm) by Deborah Christensen Secor

painting children from photographs

Because children are not good at holding still, most artists who paint portraits of children use photographic references. The key to success in painting from photos is good reference photos. The better the photography, the better the portrait. It's best to take the photographs yourself. Your observation of the children as you photograph them will assist you in the subsequent paintings. In some cases it may be possible to make quick sketches from life.

preparing to sketch
Greg Biolchini sketches his subjects from a slide viewed through the screen in his projection booth. This preliminary drawing stage was done with a light sepia-colored pastel pencil. Note the easel is tilted slightly forward at the top so the pastel falls away from the painting surface rather than streaking it.

materials list

pastel pencils

French Red Ochre, Payne's Gray, Caput Mortuum Violet, Burnt Sienna

pastels

brown, cocoa brown, dark burnt umber, middle value burnt umber, light burnt umber, cool middle-value gray-pink, warm light yellow, light pink, middle-value burnt orange, dark cadmium yellow, cordovan, dark cool blue, dark blue-violet, dark warm gray, middle-value warm gray, light warm gray, indigo-blue, dark warm green, middle-value olive green, black, dark gray-red, dark raw sienna, middle-value raw sienna, light raw sienna, dark gold-ochre, middle-value gold-ochre, light gold-ochre, dark yellow ochre, middle-value yellow ochre, light yellow ochre, dark Mars violet, middle-value Mars violet, light Mars violet, dark burnt sienna, middle-value burnt sienna, light burnt sienna, dark red oxide, middle-value red-oxide, light red-oxide, dark cool rose, middle-value cool rose, light cool rose, dark orange-red, middle-value orange-red, light orange-red, dark caput mortuum, middle-range caput mortuum, light caput mortuum, dark gray-green, middle-value gray-green, light gray-green

1 Draw the Subjects

Draw the subjects slightly less than life-size to give them the appearance of being set back into the painting and strengthen the illusion of depth. Measure the children's heads with calipers to ensure accuracy. Keep in mind that children's proportions are much different from those of adults. Lightly sketch the initial drawing, but once the placement and shapes are correct, redraw and establish the darks using a slightly darker hard pastel (such as Cocoa Brown), removing any erroneous marks with a kneaded eraser. The girl's stuffed toy cat was added for balance.

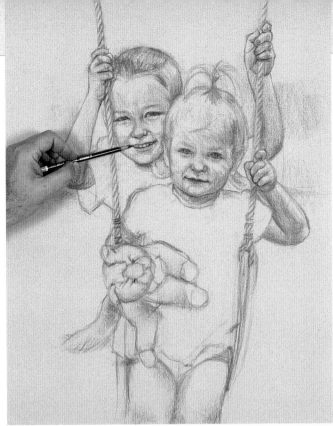

2 Block in the Darkest Values

As you work, it can be helpful to check your drawing with a mirror—it may reveal drawing errors you wouldn't see otherwise.

Block in the darkest values using the sides of the pastels. Because this paper has very limited tooth, it's best to stick to harder Nupastels in this first stage.

3 Add Color

Make color selections by matching them to the colors in the reference slides. Good color selection comes from observation, not from systems, formulas or rules. Work in dark to middle values at this stage.

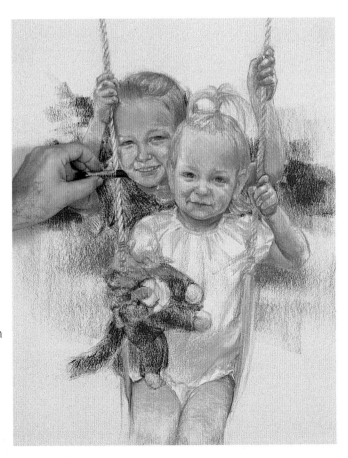

4 Darken the Color Values

Begin to darken the dark values with slightly softer pastels, including Burnt Umber, Burnt Sienna and Raw Sienna.

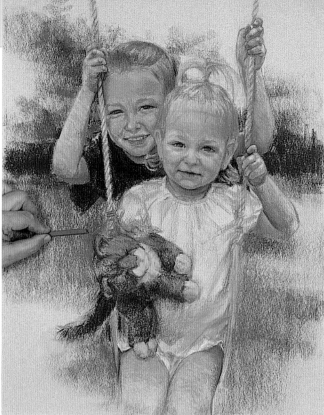

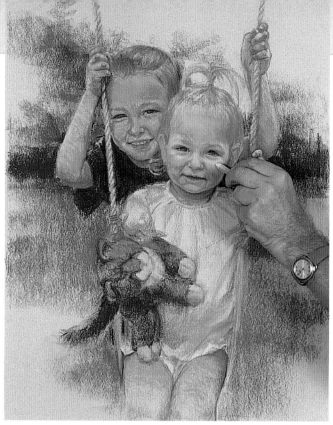

5 Develop the Background Color

The impression of background foliage should be built up carefully, using greens and olive green held on their sides for a light touch. Painting the background as the portrait develops keeps the painting a whole, rather than creating a feeling of distinct separation between the background and foreground.

6 Build Up the Lighter Values

Use very light pressure to preserve the tooth of the paper and build up the lighter values gradually. Look at the reference slide to see where each color appears, placing it throughout the painting as needed. Using each color in more than one area creates harmony.

Use a light pink for the trim on the girl's blouse. Be careful when selecting cool pinks—some pinks fade in less than six months. Add light to the girl's face. Lightfastness ratings of each color are available from pastel manufacturers.

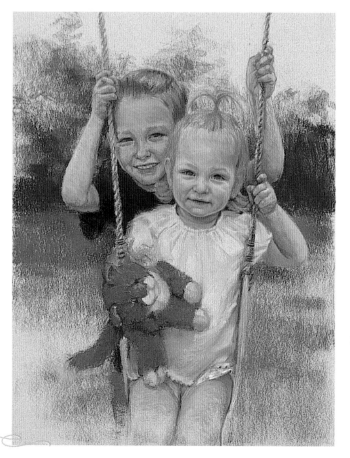

7 Add More Color

Use the sides of pastel sticks to make the broader strokes in the little girl's shirt, the stuffed toy cat and the background.

8 Refine the Details

Lay in lighter flesh tones in the girl's face and hand using peach and other light-colored pastels. Use very light pressure and blend them into the previous middle value layers to continue to produce lighter colors and edges.

The stuffed cat is adjusted with a darker gray pastel. You can use black under another color for a darker shade, but use black with caution. For example, using black in the boy's blue shirt produces a darker blue when blue is painted over it.

Build up gradually into slightly lighter colors throughout the rest of the portrait, adding a middle-value Yellow Ochre and Raw Sienna in the girl's blonde hair. The middle-value Yellow Ochre in the light parts of the girl's hair appears lighter than it really is because of the darker colors around it. Brown is used on the boy's hair. Fine-tune faces, arms and hands, focusing on middle values.

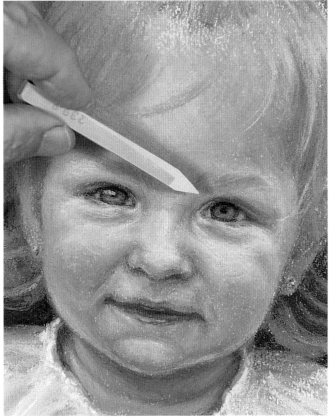

10 Concentrate on the Faces

At this stage you can use sharpened pastels. You can achieve a very fine point on a pastel stick by rubbing the tip of the stick across a medium-grid dry-wall-sanding screen. The sharpened pastels make it easier to achieve delicate details, which is especially important in rendering children's facial features.

It is rarely necessary to rub pastel portraits with fingers or stumps, but use the occasional touch of a finger here and there when absolutely necessary, as in the case of this girl's delicate and subtle features. Refine the faces with peach and other light-colored pastels, using them to layer and blend.

With a sharpened warm, light gray pastel, place highlights in the eyes. Be careful not to make the highlights too large or too light.

9 Lighten the Background

Soften the background greens using a gray-green pastel, very nearly the same color as the paper.

11 Finish the Little Girl's Face

Soften some of the shadows in the little girl's face, particularly around her eyes and mouth, by blending the pastel together and softening the edges with a fingertip. Be careful: Too much rubbing and her features could lose definition and become blurred.

12 Add Details to the Boy's Hand

For the lightest tones in the little boy's hands and fingers, use a slightly softer pastel. Using a softer pastel makes it possible to continue layering on more pastel after the paper's tooth is filled from prior layers. Once the tooth is lost, it's impossible to continue layering with slightly harder pastels.

13 Finish the Portrait

Instead of spraying the finished portrait with fixative, give it a couple of good flicks on the back with a finger to dislodge any loose pastel particles. Fixative dulls and darkens pastel colors, which would detract from such a lively portrait.

With all the finishing touches in place, the artist signed and dated this portrait in the lower right-hand corner. On portraits, the artist includes the date for posterity's sake.

Portrait of Anna and Sean
25 ½" × 19 ¾" (65cm × 50cm) by Greg Biolchini

painting from life

Why paint from life when photos are available? Well, there is no greater teacher than life. No camera can capture the subtle nuances of color and light as it touches the skin of a model, hits a copper pot on a table or falls on and describes the forms of the landscape. The more painting you do from life, the stronger all your work will be.

I paint the landscape from life as often as possible, and have learned to set my easel and supplies in the smallest possible area—sometimes on the edge of a sidewalk in a village in a foreign country, sometimes on the edge of a cliff where I dare not back up, and once balanced precariously on rocks in mid-stream.

When you paint in view of the public, comments are inevitable. Some of my favorites have been in foreign countries, where my limited understanding of the language still allowed me to appreciate the "Bella!" or "Trés jolie!" Once a small, solemn boy of about five years of age studied my painting quite carefully before pronouncing it "very good." Another time, my critic was a silent but intent hummingbird, who apparently found the selection of pink and red pastels arranged in my pastel box quite attractive.

Cortona Hillside
8" × 11" (20cm × 28cm)

painting a figure from life

Painting a model outdoors presents several exciting challenges. The changing light affects the colors of the landscape as well as skin tones and colors of fabric. Wind may gust and subside; clouds may pass by, each changing the way light describes the forms. Working quickly and staying with your decisions will make the process easier.

Make a Reference

Artist Bill Hosner never uses photographs, except for the purposes of showing the initial view of the scene. He has painted only from life for many years. This demonstration was completed in one session, in a little less than three hours.

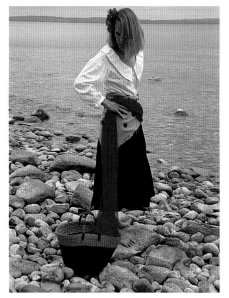

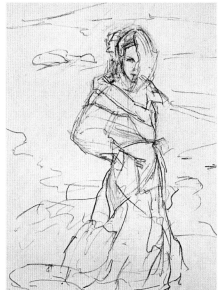

1 Draw the Subject

Using a pastel pencil, sketch the placement of the figure. The drawing will be covered entirely by pastel, but accurate placement of the figure and its relationship to its environment will make the subsequent painting easier.

The initial sketch gives you a map for the painting. Compositional changes are much easier to make before applying pastel.

Reference Photo
Even when creating a painting from life, it's helpful to have a photograph of the original scene that caught your eye. By the time this artist began to sketch the composition, the wind had picked up and the scarf was blowing.

materials list

White Professional Grade Wallis Sanded Pastel Paper

pastels

gray-greens (light, medium and dark), warm grays (light, medium and dark), cool grays (light, medium and dark), carmine brown dark, burnt sienna, dark burnt umber, dark raw umber, light red oxide, carmine red medium, permanent red medium, warm black, cool black, dark red purple, light burnt sienna, light ultramarine blue, light and medium red-violet

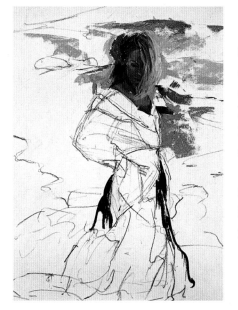

2 Begin Applying Pastel

Quickly apply color with pastel. Since the head is the center of interest, start by blocking in the general colors of skin tone, hair color and so on. Establish the parameters of the lightest light, the darkest dark, and the basic colors and edges.

Keep the background relating to the figure by putting the colors of the scene behind the model around the areas you're working on.

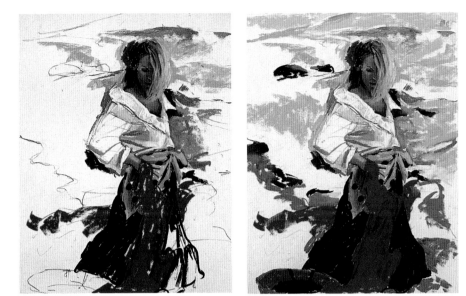

4 Develop More of the Background

With the figure blocked in and some areas nearly completed, pay attention to the background landscape and block in the rest of the colors. As you work near the edges of the figure, you may need to rework some areas to keep the figure and background integrated.

Place the general background colors, working quickly to cover the entire surface.

3 Block in the Rest of the Figure

Since working outdoors means changing light—which will affect colors—block in the figure quickly. The black skirt, white blouse and red scarf can be painted loosely, but watch for color and value shifts that help describe the form of the clothing and the model. As you develop the clothing, look for where the landscape touches it and begin putting those colors in.

Note how the scarf is blowing in the wind. Once you paint an object like this that might move later, stay with the decisions you made. If the wind dies down, don't change the position of the scarf if you've already drawn and painted it.

5 Add the Finishing Touches (But Not Too Many)

As the light begins to change, work toward finishing the painting. Remember that most paintings done outdoors are looser and less detailed than studio work. Capturing the feeling of the landscape, the air, the wind blowing and the quality of light is what makes paintings done outdoors magical and exciting.

Keep the strokes broader and the background more abstract to avoid competing with the figure, which is the focal point of the painting. Touch up edges and make any final corrections.

Sleepless Winds
11" × 14" (28cm × 36cm) by Bill Hosner

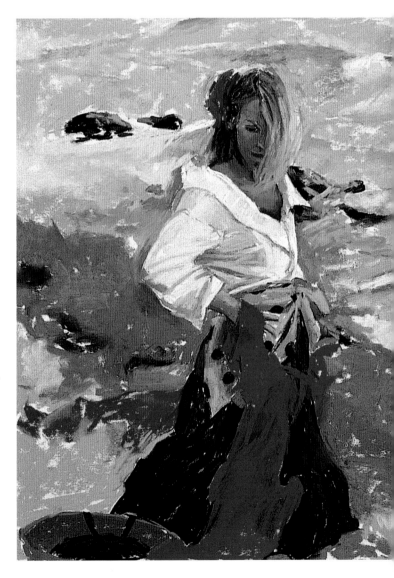

painting a model in your studio

Artist Sam Goodsell likes to work at life size or nearly life size. He feels that working this way helps him learn more about painting the figure. Whether you choose to paint the full figure, a three-quarters figure or just a head, try working at life size.

sam goodsell's surface recipe

To make this surface, mix the following ingredients together in a container that has a tight-fitting lid for storing any unused mixture:

- 2 parts gesso (a good professional gesso, not student grade)
- 1 part water
- 6 tablespoons of FF grade pumice (more if you are making a large mixture)

Stir the mixture until the pumice powder is completely mixed in, then tint with acrylic paint to create the surface color you like. Goodsell likes to mix black and yellow to make a warm gray.

materials list

Bienfang ¼-inch thick Gatorboard (4x8) trimmed to size with a matte knife and metal edge ruler

Foam board (½-inch) for additional support

Acrylic gesso and fine pumice (type FF) mixture, tinted to middle value Green Earth with acrylic black and yellow mixed in, for Gatorboard surface (applied with 5-inch foam brush)

Vine charcoal shading stump, chamois cloth rag, Plumb bob, maulstick

pastels

low to high value red earths, indian reds, pale green earths, low to high value raw siennas, low to high value burnt siennas, low to high value warm grays and blue grays, raw umbers, burnt umbers, low value ultramarines, black

Preparing the Surface

This painting is done on Gatorboard prepared with a pumice/gesso mix, but you can also brush the mixture onto a four- or eight-ply museum or illustration board. Unless the board you're using is quite rigid, coat the back with gesso to prevent warping and apply two or more coats of the mixture to the front. Let the surface dry completely before beginning.

1 Draw the Figure

Cover the surface of the paper evenly but lightly with a large piece of soft charcoal. With a stick of soft vine charcoal, begin sketching the figure. Once the major gestural strokes define the figure broadly, use a chamois cloth to define the light areas by lifting out some charcoal. Work to define the placement of the figure on the surface by identifying the center line of the figure, the position of the rib cage and pelvis and the gesture or movement of the figure. This preliminary drawing should be very loose.

2 Refine Your Drawing

Continue to darken the major shadow areas with the soft vine charcoal, but keep the drawing loose. If you are drawing the full figure at life size, you may need to use a mahlstick to support your hand and prevent smudging already-drawn areas.

After the drawing is complete, check the measurements of the model against the drawing. For example, using the size of the head as a base, the entire figure in this instance is seven and three-quarters heads high. Measure the distances of other body proportions in the same way to ensure accuracy.

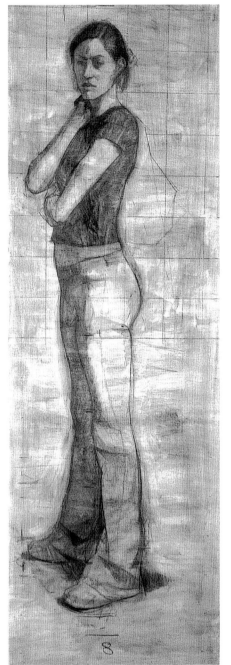

4 Block in the Local Colors
Begin the block in with the major shadow shapes, and color them as accurately as possible. Keep the shapes large and simple. Work in the background colors at the same time to keep color harmony between foreground and background. Work from the darkest to the lightest values. Block in the big shapes of the features of the face in the same way, dark to middle to light values.

what's a mahlstick?

Whether you paint in a large format like Sam Goodsell, or a small format, there may be times you would like to rest your hand on the painting to steady it as you add pastel. Of course, laying your hand on the surface of the painting would likely blur any completed portions, not to mention putting unnecessary color on your skin!

The solution is a mahlstick, traditionally made of a long dowel-type pole or stick of wood with a round pad at one end. To use it, rest the round ball-shape pad on your backing board away from the pastel painting, and then hold the other end up with your non-painting hand. Rest your painting hand on the stick and apply the pastel.

Today, some mahlsticks are made from aluminum. A great and inexpensive substitute is a walking cane with a curved end. Hook the curved end over the top of your backing board and you've got a perfect support for your hand.

If you just have a couple of changes to make, you can tape a piece of paper or glassine to your backing board so that it covers the area where you want to rest your hand.

3 Finish the Drawing
When the drawing is complete, the major areas of light and shadow as well as the forms should be defined.

changing the composition
Note the position of the model's left arm at this early stage of the painting. At a later session, the artist decided to make a change in the way the arm was held.

After you've begun applying pastel, it's not too late to make changes to the composition. Goodsell decided that the model's left arm was held too tightly to her body, and he asked her to move it a little. The change in position allowed part of her left hand to show and gave her a more relaxed look.

5 Refine the Color

Pay attention to the warmth and coolness of your colors as well as to their values. For instance, the model's skin color includes cool pinks and greens. Shadows can be an intermingling of warm and cool, depending upon the skin tones of the model—they are not usually just one or the other. Working under natural northern light shows the luminous tones of skin colors.

Build up the colors with multiple pastels, layering one over the other as necessary to achieve the correct colors and values.

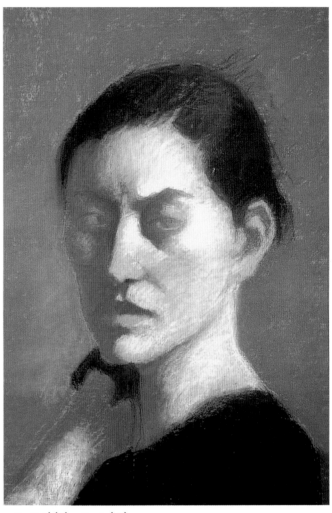

6 Build the Facial Planes

First block in the eye socket, the shadow of the nose and the chin, then begin working to refine the forms. Pull out the shape of the eye and the planes of the nose. Try to think of pulling the form out of the paper like sculpting from a block of clay; it will give your work a dimensional feel. Pay attention to the structure of the face—for example, this model has large eye sockets and a relatively long nose. The character of the subject comes out in the face.

Model the planes of the face, paying attention to temperature as well as value. Note the "lost edge" of the mouth on the left and how it adds mystery to the face.

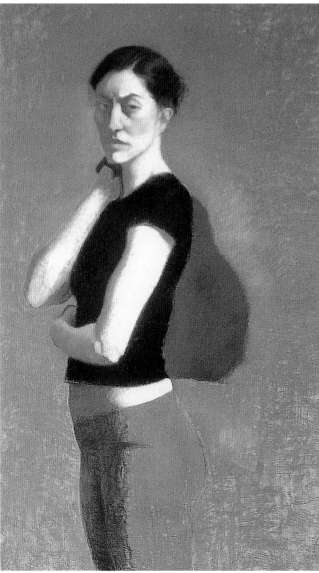

7 Adjust Colors and Forms

Work from the top down and make adjustments as needed. Observe the subject carefully; it's never too late to adjust the color or even the drawing. When you make a color adjustment, it's not usually necessary to remove the previous color. Layering a new color lightly over the top is generally sufficient.

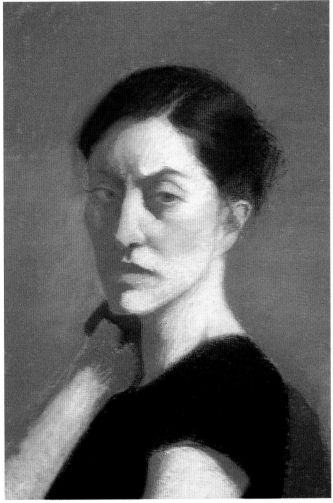

capture the mood
Don't paint every element to great detail: Some large areas left as simple shapes make a painting strong. The emphasis should not be equal all over—some things should be emphasized and others diminished. Too much detail could lessen the impact of the painting. Concentrate on catching the feeling and character of the model, including mood and expression. That's often more important than making every detail correct. Making a great painting is not just about technique and skills; they are important, but the feeling of the painting is also important, and that's captured only by careful observation.

8 Finish the Painting
As you work toward completing the painting, observe the model, compare her to the painting and see what else needs to be done. Look for color and form accuracy, but also look for places you could "lose" or "find" edges. Not every edge of every shape should be a crisp hard edge or line. Soft or lost edges add mystery to the painting.

Your painting is finished when you can't see anything else that needs to be done or that could improve it—when everything you feel needs to be said has been said. That doesn't mean every detail is included down to the seams of the clothing, but it does mean that what is necessary is there.

Gloria
96" × 26" (244cm × 66cm) by Sam Goodsell

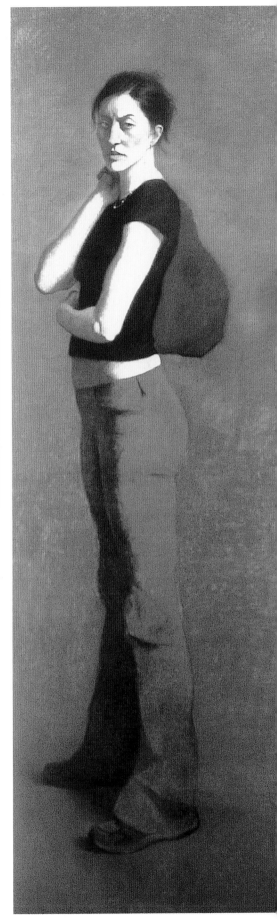

painting a still life

Deborah Bays's demonstration of a still-life painting is planned as a chiaroscuro, or light and shadow, painting. She has chosen a horizontal composition so that the viewer's eye follows the light falling on the objects from left to right.

The demonstration painting was painted in natural light. North light is cool and the shadows are warm, so the light shape in the painting will be cool in relationship to the shadow shape. The reverse is true for most artificial light.

The color of the photograph is different from that of the painting. Natural north light can't be adequately captured in a photograph. For the photograph of the setup, the natural north light was enhanced with artificial light.

materials list

White Wallis Sanded Pastel Paper

pastel pencils

Warm white, Light warm brown, Dark brown, Black

hard pastels

black, warm gray, warm gray green, ochre or deep gold, medium warm brown, medium warm yellow, light warm yellow, medium warm orange, light warm orange, medium warm red, deep red, warm light green, warm off white

soft pastels

Same as the above list of hard pastels, with the addition of white

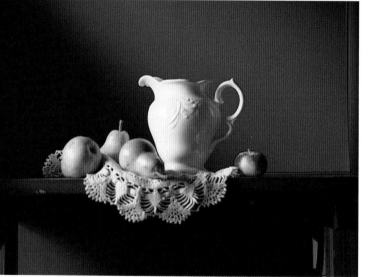

1 Set Up the Still Life

The lightest object, the milk pitcher, is set in the focal area at the right side of the composition to strategically lead the viewer across the entire painting. The focal point in a painting is created by placing the greatest contrast in value, the brightest, warmest color and the tightest edges in one area. It is the area of the greatest development and clarity of detail. The last shadow on the far right side, which falls on the apple, stops the viewer's eye from traveling out of the composition.

2 Draw the Composition

Begin with a minimal but accurate drawing, working on white Wallis Sanded Pastel Paper. This first simple drawing is important to capture the placement of the objects, as well as for a good start on a realistic depiction of the man-made objects. Organic objects such as fruit are more forgiving. The preliminary drawing may be a bit generic; the more specific drawing happens later in the painting process.

A loose drawing gives you a chance to accurately place the objects on the paper, revising as needed before applying pastel.

3 Block in the Values

This painting is based on two shapes, the light shape and the shadow shape. To begin defining these shapes of light and dark, squint at your setup. Find the abstract design created by these shapes; try not to think of drawing or painting specific objects like pears or pitchers. Instead, think of painting the light or the shadow. Choose a soft, neutral color to block in the shadow shape. Leave the light shape the white of the paper, so that your bright and light colors will be pure. This is the time to make any corrections to your composition.

Block in the darkest shapes using a soft, neutral pastel. If you use a somewhat harder pastel such as a Nupastel, you do not need to worry as much about filling the tooth.

4 Rough in the Dark Shape

Choose a dark, warm tone in either a hard or soft pastel. It may be necessary to layer with several sticks of pastel such as a dark, rich black and a dark, warm brown. It is important to make this shape very dark so that you can work some slightly lighter values of pastel over it to create depth and atmosphere later in the painting process. The dark shape should remain relatively simple in comparison to the light shape. Work carefully so as not to lose your drawing or obscure the value structure.

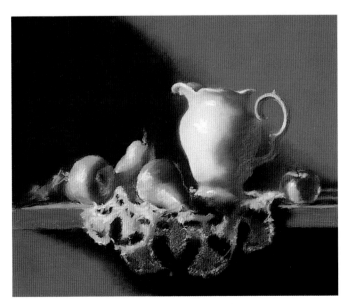

5 Begin Painting the Light

Working with harder pastels at this stage will help retain the tooth of the paper, allowing for better adherence of pastels in subsequent layers. Begin by painting the local color of each object. Where the form of the object turns away from the light—adjacent to the shadow—you will see an area of richer color. Note that this is true for folds in fabric, also. This is the halftone. Add this color and blend it slightly into the shadow shape.

Next, paint the highlights. They should have sharper edges on shiny surfaces and softer edges on matte surfaces. It's important to add the highlights at this stage because all of the values in the light shapes must be darker than the highlights. Also, check to make sure that every value in your light shape is lighter than the values in the dark shape. This is the time to make any necessary value adjustments.

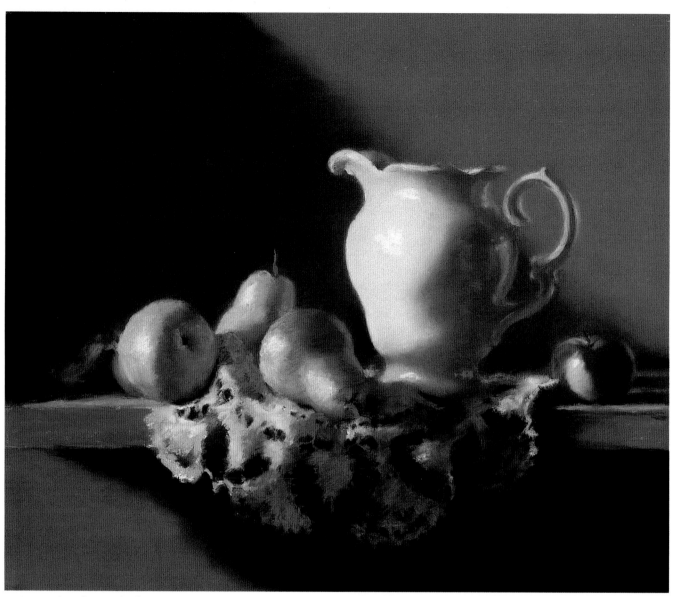

6 Develop the Dark Shape

Use softer pastels for this step, and begin with the shadow area behind the objects. Work over the first dark layer with a warm tone of a slightly lighter value. This will create the illusion of atmosphere and a receding background. Think of painting this light over the layer of shadow. Technically this natural north light is cool, and lightening the value while using a warm tone keeps the shadow shape cohesive and cools it slightly.

Tone the dark shadows on each object with a bit of rich, dark local color. Keep this subtle so that the shadow shape still reads as a cohesive unit.

There is light reflected on the objects and folds from adjacent objects, and in the case of this painting there is also light from a secondary light source to the right side of the objects. Although the reflected light may appear light in value, it visually remains in the dark shape and therefore must be of a darker value than any value in the light shape. Paint this in a subtle way, blending the pastel so that the shadow shape remains visually cohesive.

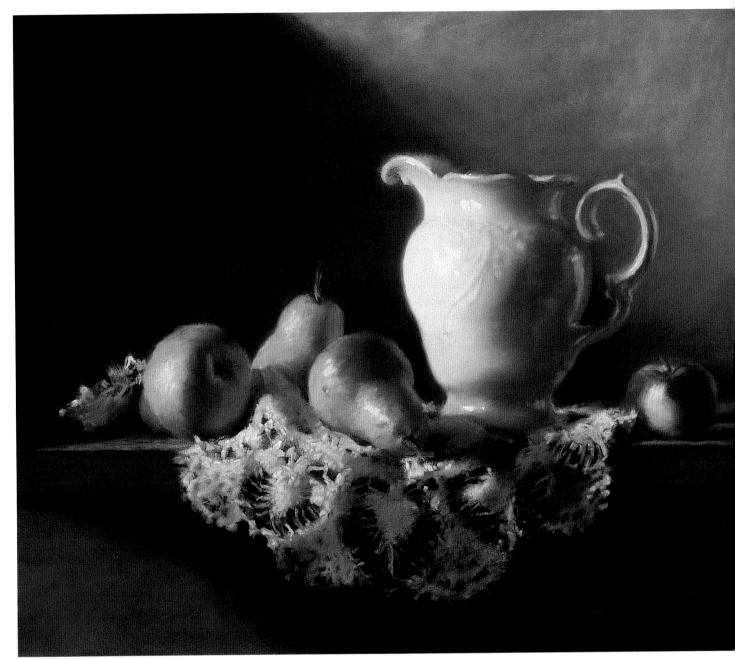

7 Finish the Painting

Using soft pastels, paint a lighter value of pastel over the light area behind the objects. This color will need to be slightly cooler because you are painting the light. Since this area is lit, it may be more textured, patterned or detailed than the shadow area of the background; however, keep it subtle to further the illusion of atmosphere.

Paint over the objects to further develop subtleties in gradations of color and value. Remember that you are not painting objects, but rather light falling on objects. Keep gradations simple and add detail in the focal area. For example, Bays developed the raised design on the milk pitcher. Detail is a matter of painting smaller shapes and tighter edges that attract the eye of the viewer.

Make the edges sharper in the focal area, then examine the edges throughout the rest of your painting. The edges of shadows closest to the light source will have hard edges that soften as they move away. The edges of cast shadows are hardest closest to the object from which they are cast. This is true as well for the light falling on the background. The edges are all relative to the tightest edges in the focal area. Retouch the highlights so that they are pure, clean and cool in relation to the other light colors.

Milk Pitcher with Pears and an Apple
13" x 16" (33cm x 41cm) by Deborah Bays

painting outdoors

If you're interested in painting landscapes, there's no better way to learn than to go outdoors (often referred to as "plein air" painting). You'll see nuances of color and shadow that you will never find in a photograph. And there's something about being there—outdoors with the breeze, the sound of the birds chirping, the feel of the sun—that magically translates into the painting and gives it a feeling of authenticity.

If you've never painted outdoors you may find it intimidating, but take the plunge and give it a try. In the beginning, your paintings may not come out the way you hoped, but you will learn from every painting. When you return to the studio all those things you observed and learned on location will integrate themselves into your paintings done from photographs.

There are two very valuable things to think about before you move outside:

1. **Keep your equipment light and portable.** When you find that perfect spot to paint, you don't want to spend the first hour hauling equipment and supplies. Most artists carry too much in the beginning. Try to keep your setup to a minimum, and after each of your first outings, take inventory to see what you didn't use. Omit those things for the next trip. Ideally, you should be able to park your car, carry all your equipment in one trip, and be set up and ready to paint within about ten minutes. It may take some trial and error to reach that goal, but keep at it—you'll find it worthwhile.

2. **Work small and work fast.** Unless you're painting in the middle of the day, the light will change in about an hour. So work small—9" × 12" (23cm × 30cm) or perhaps 11" × 14" (28cm × 36cm)—and you'll be able to get a good painting before the light changes. Don't worry if it's not as "finished" as your studio paintings. Just consider whether you have a good representation of the subject, the color and values, and the light and feel of the place.

using a viewfinder

Using a viewfinder when you begin your drawing will make the job much easier. A piece of scrap mat board or foamboard with an opening proportional to your paper will work. I use a Picture Perfect Viewfinder, which has openings with squares of transparent acrylic, marked with a grid. The grid gives a quick reference for composition—it's easy to make sure the center of interest or focal point of your painting is not in the center of the composition, since the center is marked.

No matter what kind of viewfinder you use, hold it up and note where the focal point or center of interest is, and how the subject fits into the viewfinder. For example, with this subject, note that the mountains fall an inch or so below the top edge of the viewfinder; that the contrast of the small group of light-colored reeds and the shadow behind them is left and a little above center. Note where the edges of the viewfinder mark the edges of the composition, and sketch all these reference points lightly and quickly onto your paper with a piece of extra-soft vine charcoal.

Choosing Your Subject

The best time of day to paint is often either morning or late afternoon, when there are strong cast shadows. Look for a simple but strong composition, keeping in mind that you can make changes—but keep those changes to a minimum. You don't want to struggle with fixing serious compositional problems while trying to do a quick outdoor painting.

Using a viewfinder is helpful. The first viewfinder you use will probably be the one on your camera. Looking through that viewfinder helps you isolate a subject from the vastness of the landscape around you. When you find the subject you want to paint, take a photo of it for later reference.

equipment for painting outdoors

Less can be more when working outdoors. Here's a summary of what you need:

- A lightweight, portable easel
- A lightweight box to carry pastels
- Pastels. You don't need all the ones in your studio: A selection of 100 to 200 colors should be plenty. Select an assortment of brands so you have a variety of hardness and softness. A good basic setup will include five to ten values of each of the primary, secondary and tertiary colors, plus a range of earth colors and grays. Using half or a third of sticks reduces the weight and space required
- Paper. Whatever your favorite paper, take a few pieces cut to size so you don't have to do that outdoors
- Backing board
- Tracing paper pad to store finished paintings for transporting
- Folding table or other means to hold your pastel box within reach
- Viewfinder
- Masking tape
- Barrier cream or gloves
- Bungee cords. I strap a bungee cord across the center brace of my tripod and hang my bag from it to keep the easel from tipping over in a wind
- Umbrella. If your painting surface is in full sunlight, you'll tend to paint everything too dark and with too strong a contrast. And if your painting surface and pastel box are in different light conditions, it's harder to accurately choose pastels
- Camera
- Personal items: hat, sunblock, bug repellent, sufficient water and perhaps a snack

This may sound like a lot of equipment, but it will all fit nicely into a medium-sized roller bag and a tripod bag.

setup and preparation

If you're painting during a time of day when there are long cast shadows, that means the light will change quickly. Set up your painting gear as fast as possible, and begin painting while the composition is still as it was when you chose it.

If possible, angle your easel so the light is not hitting your painting surface or box of pastels. If you have an umbrella, you can use it to create shade for either or both.

learning from the landscape

There are often times when you'll be outside in a beautiful place, but you can't paint. Perhaps you're with family or friends, or hiking and unable to carry your painting gear, or even just riding in a car along the highway. When you see something interesting in the landscape but can't paint it, try "practice painting." Practice painting is a way of visualizing how you would paint the subject. Study the view that's caught your eye and ask yourself the following:

- If you were to paint this, what would be your center of interest?
- Where would the edges of the composition be? Are there natural directional lines or movement to lead the eye into the composition, or could you rearrange a little to create those?
- Are there other changes that could be made to create a stronger composition and help the viewer grasp what drew you to the scene?
- What is the value structure of the subject? More dark values than light, or more light values than dark?

- Where is the darkest dark, and where is the lightest light? Do they naturally fall together at the focal point, or would you have to make changes to place them there?
- Which direction is the light coming from? What is the color of the light, and is it warm or cool? Are the shadows long or short? Are the shadows cool or warm?
- Is there wind? If so, what direction is it coming from? Are any tree branches leaning in response to the wind? Can you see movement in the clouds?
- What is the mood of the subject?
- Where would you start with the painting? Visualize each step.

These practice paintings will help you learn more about the process. Asking yourself these questions and working out the answers, along with visualizing the progress of the painting, will make all these things more automatic the next time you're out on location and able to paint in reality.

painting the landscape

The first time you move outdoors to paint, you may feel a bit intimidated by the vast landscape before you. But every painting done outdoors will add to your knowledge of the landscape, so take the plunge and give it a try. If you don't worry about each painting being a masterpiece, but instead concentrate on learning something from each one and collecting information, you'll take the pressure off and can enjoy the process.

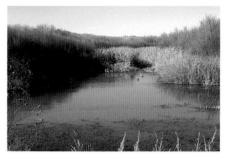

reference photo
A photograph of your painting subject will be helpful if you want to tweak a few details after you return to the studio, or if you want to make a larger painting later using the photo and your on-location painting as reference.

materials list

Belgian Mist Professional Grade Wallis Sanded Pastel Paper

Extra-soft vine charcoal

Viewfinder

pastels

very light slightly warm blue, light cool blue-white, light cool blue, middle-value cool blue, middle value blue, dark-middle blue, very light blue-gray, light pink-gray, light lavender-gray, very light yellow-white, light yellow, yellow ochre, middle-value yellow-orange, dark yellow-ochre, middle-value brown, middle-value yellow brown, dark brown, dark reddish brown, very dark brown, light orange, light reddish orange, middle value orange, middle-value red orange, dark orange, dark red-orange, middle-value red, dark red, middle-value magenta, dark magenta, very dark purple

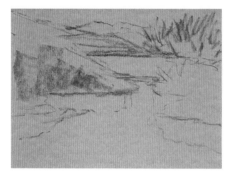

1 Sketch the Scene
To keep from making value judgment errors in the bright sunlight, use a neutral-value paper. Use soft vine charcoal to begin your sketch. Don't spend too much time on it—just get the major shapes and positions indicated. Note that the distant mountains, clearly visible from the painting location, were not as visible in the photograph.

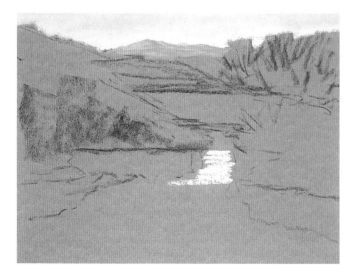

2 Begin Adding Color in the Distance
Establish the color and value of the sky first—this will help determine the values of everything else in the painting. These sky colors are a combination of a light blue pastel and a slightly darker turquoise pastel. Make a color note of where the lightest part of the sky reflects in the water to save you from having to find that pastel later.

In terms of value, the distant mountains relate more to the sky than the closer land masses visible in this subject, so paint them now. Because it is late afternoon, just an hour or so before sunset, they have a pink cast on the sunlit side and a purple-blue shadow on the other side. For the mountains, use a lighter pink and a blue-gray, enhanced with a touch of purple-gray.

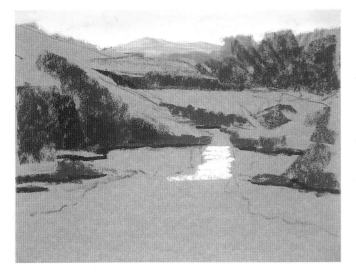

3 Place the Darkest Values

Place the darkest values of the shadows and foliage. Remember, when using pastels you can always lay a lighter value over a darker one. In the area of foliage in this image, laying the darks in first will help you create the feeling of the light hitting some branches and not others; it will also give depth to the painting.

The darker values of shadows and foliage are laid in with dark browns and reddish brown pastels.

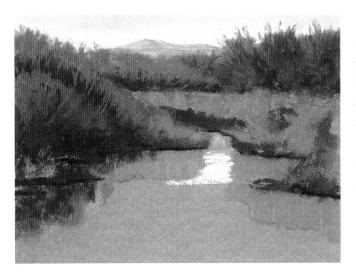

4 Move Toward Middle Values

When you're working outdoors, you work fast to catch the color and values before the light changes. If this were a large painting done in the studio, you might spend more time on each stage. But it's small, and the sun is about to set, so quickly place those middle values of orange and yellow.

Where the light touches the reddish brown bushes, it turns them a red-orange. The reeds in the water are all in shades of gold and yellow.

5 Paint the Reflections

Paint the reflections of the reeds in the water as you add the middle values. It's easier to paint the reflections while you have the correct pastels in your hand; don't risk grabbing the wrong color later.

Middle value reflections tend to reflect in pretty much the same value. Dark values tend to reflect a little lighter, and light values may reflect a shade darker. For instance, if you were painting a tree with a very light-colored trunk, such as a white birch or an aspen, its reflection would probably be a little darker—half a value or even a full value step darker—and a little bluer or grayer. Keep this theory in mind, but as always, accurate observation is more important than any theory!

The reddish tips of the bushes on the left appear slightly lighter in value in their reflection. There are many factors in determining just what is reflected; the angle of light and your angle of view are just two of them. Believe in what you see, and paint it as it is and not as you think it should be.

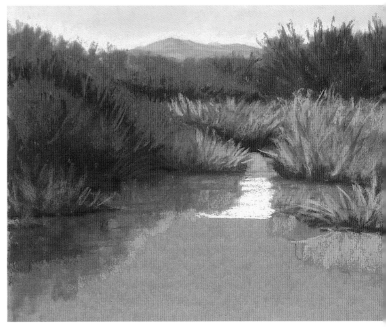

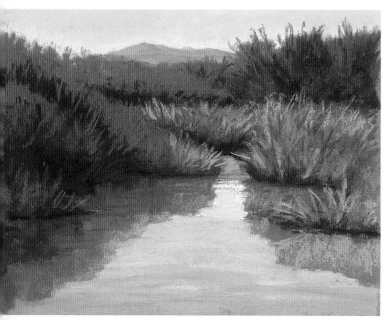

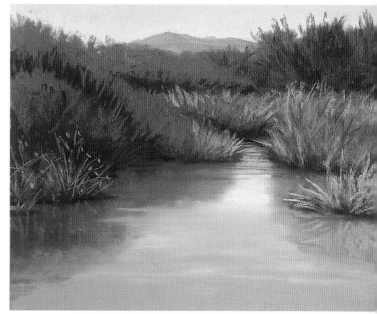

6 Color the Remaining Water

As you paint the foreground water, remember that it's reflecting the sky overhead and not the sky at the horizon. Therefore, it is a darker value than the more distant water. In a small painting like this, exaggerating that value change will give it depth. Paint the foreground water right up to the edges of the reflections.

7 Blend the Water

Blend the water down from the line of the bank at each area of reflection. I like to use the side of my little finger, with my hand held horizontally, for this first blending stroke. Don't worry if you don't blend it perfectly—you can do this more than once. Be sure to clean your finger on a paper towel after each stroke.

Then, use the tip of a finger to blend horizontally. You can blend from the blue water area toward the edges—a blending stroke from the center to the left, then one from the center to the right. A vertical blending stroke followed by a horizontal stroke will make the reflections come toward the viewer but keep the water flat and horizontal.

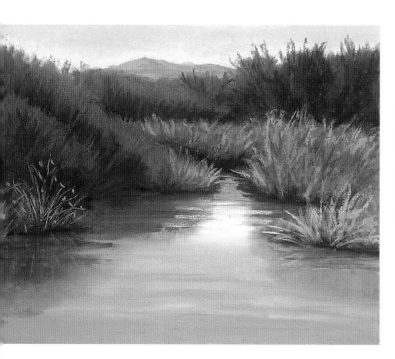

8 Touch Up Any Smears

If any smears of red or yellow got into the blue water area, touch them up carefully by adding another layer of blue pastel, and re-blend the blues as necessary using your fingers as above. A few streaks of blue going right across the reflection will help the viewer understand the difference between the reflection and the object being reflected.

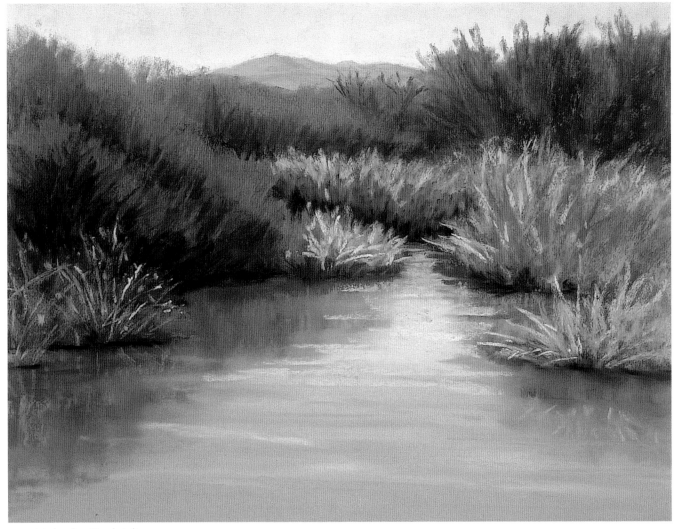

9 Make the Final Adjustments

Step back and look at the painting as a whole, and see where adjustments need to be made. The darkest values in the red bushes to the left can be darkened a little at the base, and a slightly brighter red used where the sunlight is hitting their tips. At the right, the values of the bases of the bushes where they meet the water can also be darkened a little.

Highlights are usually the last step, along with fine details. Add the brightly-lit individual yellow grasses on the left, using the side of a firm pastel in a bright yellow color. The little heads of the grasses can be made with the same pastel. On the right, add some light yellow highlights to the closer group of grasses, again with a firm pastel, this time a lighter yellow. Finally, the highlight in the center of the water where it recedes between the bushes can be brightened a little.

Once all these adjustments are made, step back and see if anything else needs a little tweaking. If not, it's done!

Last Hour Before Sunset
8" × 11" (20cm × 28cm)

returning to the scene

For a large-format painting or a more complex subject done outdoors, it may not be possible to complete the painting before the light changes. One solution is to return to the same location two or three more times, at the same time of day and under the same weather conditions, and continue painting.

Artist Bill Hosner painted this demonstration sequence over two days in the fall in Michigan. The sky changed throughout the sequence, as did the lighting to some degree, even though the artist worked at the same time of day for each painting session.

materials list

White Professional Grade Wallis Sanded Pastel Paper

pastels

gray greens (light, medium and dark), warm grays (light, medium and dark), cool grays (light, medium and dark), dark burnt umber, dark mars violet, dark olive green, raw umber dark, carmine brown dark, bronze green deep, bluish green, light red oxide, carmine red light, light ultramarine blue, light orange, light raw umber, light warm tan

taking a reference photo
Take a photo of your subject for future reference. You may finish the painting on location, but if you are interrupted and can't return, a photo will give you some reference information. Artist Bill Hosner never works from photographs, but he took this photo so you can see his subject.

the setup
A simple setup of easel and pastels is easy to transport to the painting location and quick to assemble.

1 Sketch the Scene
Use a pastel pencil to sketch the scene. Placing the horizon line below center allows more room for the figure, even though the sky and clouds will be an important part of the painting. There is no need to sketch in the sky and clouds at this point, since they will be in a different formation by the time you are ready to paint them. Keep in mind that this drawing is strictly a map for the pastel painting to follow.

2 Begin Adding Color
Paint as directly as possible, changing only what is absolutely necessary to make the composition work. Look for the darkest dark and lightest light. Place the darks first and lay in the distant ground.

The area of the figure is critical, so get the placement exactly as you want it at this point and paint the figure as completely as possible. The light may be different for the second session, so completing the figure all in one session is important. The rocks around the model should also be completed in this first session.

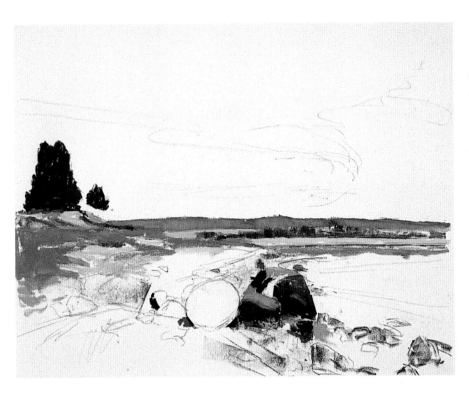

3 The Second Session
Finish blocking in the land mass and add the brightly colored umbrella, which draws the viewer's eye to the figure nestled in among the rocks. Simplify the rocks and sand, composing them into lines and shapes of movement that also lead to the figure.

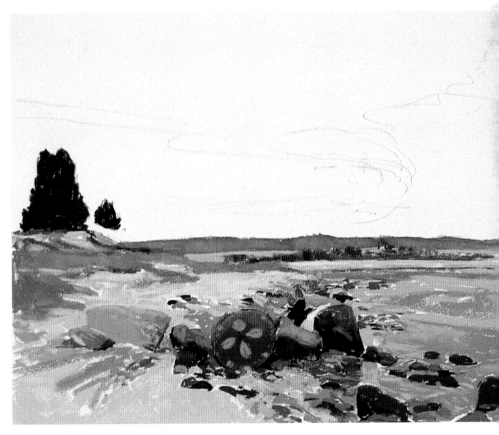

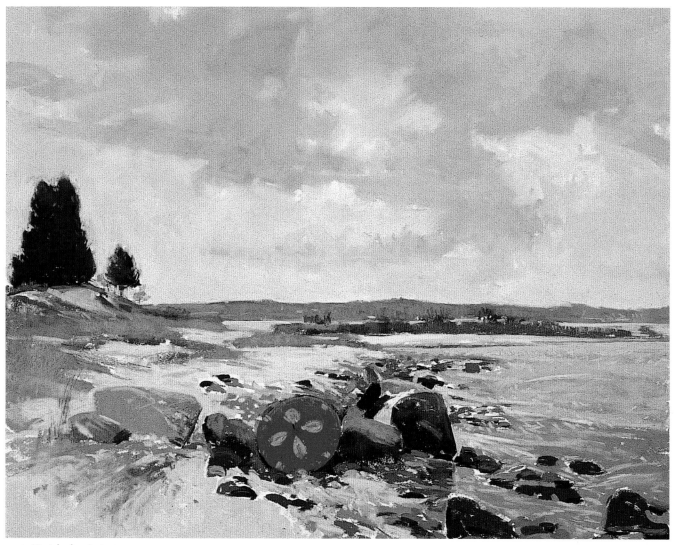

4 Finish the Painting

Painting the clouds last gave the weather a chance to provide something more interesting than the "gray blanket" of the sky the first day. When the opportunity of more interesting clouds appears, paint quickly! On cloudy days, especially when there is wind, cloud formations do not stay put long. And don't hesitate to make changes—when the spot of blue sky appeared in this painting session, the artist placed it in a position to complement the composition.

What November Brings
16" × 20" (41cm × 51cm) by Bill Hosner

landscape as still life

When the weather's bad or you can't work outdoors, you can still paint elements of the landscape from life. Try these ideas:

- Want to learn to paint rocks? Set up a few in your studio and practice. Place some rocks with varying shapes on a flat surface and move them around until they create an interesting composition. Set a lamp to cast a strong light onto them and create deep shadows. Paint this grouping and you will learn a lot about rocks of all sizes.
- You can also take a large plastic dish, such as those you place under potted plants, fill it with a couple of inches of water and set your rocks in it. This will give you a chance to observe how the rocks change color at the water line and to practice painting underwater rocks. Depending on the angle of your light source and your angle of view, you may even get some reflections.

- Fill the plastic dish with sand and set the rocks in it for another exercise. If you have enough sand to create some mounds and depressions, the cast light can give you interesting shadows.
- For practice in painting trees, bring a broken branch in and set it among the rocks. You may be able to position it to cast a shadow across a rock and see how the shadow following the planes of the rock helps define the rock's form.
- And when the weather's bad, don't forget the option of painting looking out a window. If you're fortunate enough to have a deciduous tree within your view, you can learn a lot by drawing or painting it without leaves and then again after the leaves grow out.

take the '500 challenge'

When I was at a "stuck" point in painting landscapes from photographs, I attended a painting demonstration by artist Eric Michaels. During that demonstration, he said that any artist who really wanted to understand the landscape and become a better painter should work on location. "Go out and paint, no more than an hour or so for each small painting. Don't worry about it being a finished masterpiece, just get what you can. Do that 500 times."

I took this advice to heart and headed outdoors. It was the single best piece of advice I ever had about painting. After 50 or so paintings my style had changed; after 100 the improvement in skill level was considerable; after 200 even more so. What I learned on location also began to affect my paintings done from photos, and they improved at about the same rate.

To take the 500 Challenge, follow these guidelines:
- Work small and fast; 9" × 11" (23cm × 28cm) or no more than 10" × 12" (25cm × 30cm) paper, and work for no more than an hour.

- Don't worry about finishing a piece. In order to break myself of the habit of overworking, I called my on-location pieces "color studies" instead of paintings. If I got a good representation of color and values, and something of the mood and feel of the place, I considered it a success.
- Number your paintings on the back or an edge. Keep them for some months. Then take a look at one of the first three or four as compared to number 50 or 60. Check again in a year. You'll be amazed at the changes.
- Don't let the number 500 scare you. If you do one a week, you'll see major improvement in your work in a year or less. If you average two pieces a week, you will see significant progress in a few months.
- If you live in a climate where you can't go outdoors part of the year, paint from indoors looking out, or try painting outdoor elements in the studio (see the sidebar on painting rocks). If you're painting landscape elements from life, it counts as part of the 500.

bring the outside in
Set up a group of rocks in your studio and paint them, trying different approaches of light and composition. It's great practice for learning about rocks of all sizes, and it gives you a chance to paint from life even if you can't paint outside.

using color studies as a reference

Artist Richard McKinley likes to work on location, but sometimes a painting done outdoors inspires him to paint a larger version of the subject back in the studio.

The artist spent a lot of time on location observing and studying the many moods of this landscape, its atmosphere and the play of textures in the tidal marshes. The quick study, on white Wallis Museum-Grade Sanded Paper mounted on illustration board, was done in less than an hour, with the purpose of capturing information that could be re-interpreted back in the studio.

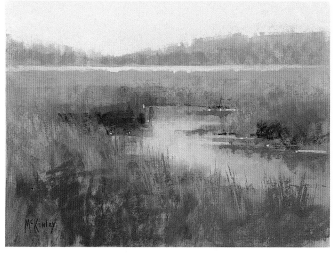

Field study, Fir Island Afternoon
9" × 12" (23cm × 30cm) by Richard McKinley

materials list

White Museum Grade Wallis Sanded Pastel Paper mounted on museum board

Nos 4, 8 and 10 flat oil bristle brushes

2b drawing pencil

Soft paper towels

watercolor paints

Cadmium Yellow, Cadmium Red Orange, Burnt Sienna, Alizarin Crimson, Ultramarine Blue, Cobalt Blue, Paynes Gray, Sap Green

pastels

light warm white, middle-value lemon yellow, middle-value yellow-orange, light ochre yellow, middle-value orange-brown, middle-value ultramarine blue, light ultramarine blue, light cobalt blue, dark blue-green, light green-blue, middle-value turquoise blue, middle-value warm green, light warm green, light yellow-green, dark orange-green, light blue green, middle-value warm violet, light warm violet, dark blue-gray, middle-value blue-gray, light blue-gray, dark violet-gray, light violet-gray, middle-value gray-green

1 Make the Sketch for the Studio Piece

If you have any concerns about the composition, make a few thumbnail sketches. Otherwise, begin a pencil drawing with an ordinary 2b sketching pencil on a piece of 14" × 18" (36cm × 46cm) white Wallis Museum-Grade Paper, mounted on an illustration board. Work out the details of the composition and become familiar with the subject. Most of the drawing will be lost once the painting is started, but this allows you a chance to make sure everything is correct before adding pastel.

Look for rhythms and movement as you explore the subject in the drawing, and make changes and improvements from the initial field sketch. For example, moving the horizon higher in the studio composition adds more distance and a stronger sense of being grounded. The addition of a closer peninsula on the far right helps balance the composition.

2 Underpaint with Watercolor

We already know that an underpainting is a way to set up the pastel painting to follow. Watercolor does not fill the tooth of the paper, so it's a good choice of medium. (Note that the paper must be mounted to avoid buckling.)

As you underpaint, think about what colors and values of pastel you will be using. Where you plan to use light pastels, underpaint the watercolor a little darker to give the pastel layer depth and richness. Remember that pastel is an opaque medium and anything you do in the underpainting can be covered, so experiment. You have nothing to lose and everything to gain.

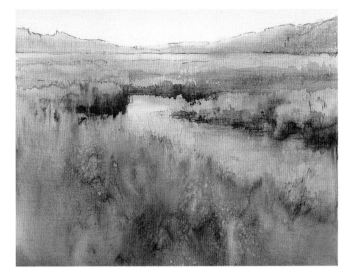

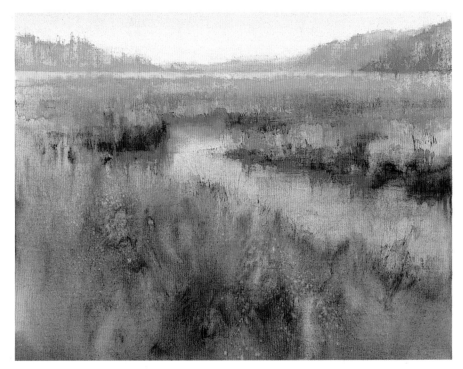

3 Begin Adding Pastel

After the underpainting dries thoroughly, you can start to apply pastel, mellowing some of the harder edges in the underpainting. Begin placing pastel around the focal point. In this composition, the focal point is located above center in the left side of the painting. Think about how you can use color and value to indicate aerial perspective—cooler, grayer and lighter colors in the distance and warmer, saturated and darker ones in the foreground.

Try not to just fill in the underpainting—use small strokes and bits and pieces of color to create texture and color. Lost and found edges are much more believable than overly rendered outlines. Since more can always be added it's best to start in a softer, broken fashion, and refine just as much as necessary to complete the form. The beginning should be very soft; you'll add more definition later.

To get rid of any strong pencil lines left from the drawing, use a light application of pastel and blend the color a little with a paper towel.

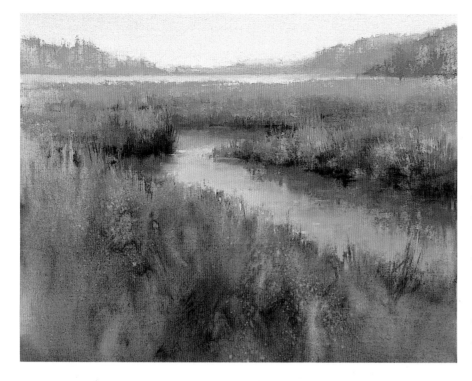

4 Refine and Move Forward

Begin painting the reflection of the water to create the shore. The underpainting works well for the grassy bank, so leave it until the end to resolve. If you paint it now, you could overwork it and lose the underpainting altogether. The water and bank are part of the center of interest, so paint them with stronger color notes, value contrasts and sharper edges.

Add more contrast to the distant water against the shore. Lighter values and more colors of similar value add importance, so add more violet to the distant marsh. As beautiful as the foreground and background are, this painting is about the mid-ground.

5 Complete the Foreground

Slowly paint the foreground—if you add too much pastel, the underpainting will be lost. Keep in mind the area of interest and avoid overworking other areas. Remember that the focal point is defined in part as the area of most detail.

Add more texture to the water surface with strokes of pastel, and continue to refine the reflections. The first indications of light sparks—those little twinkles of light where the sun hits the water and sparkles—and separation between the water and the shore can now be placed. It's easy to get these too perfect and lose the sense of movement and air. Slight smudging helps, as does varying the pressure of the pastel.

Make any small adjustments you see fit now—each stroke of the pastel counts. Ask yourself this question: Will more help or hinder?

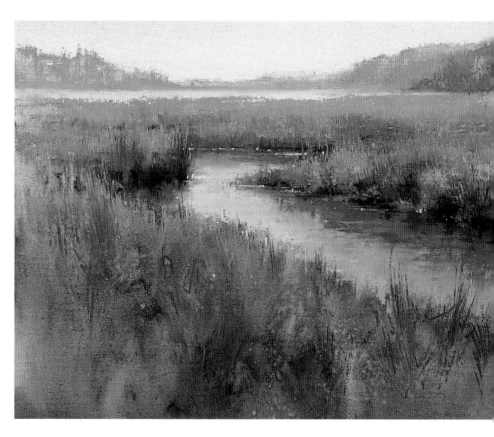

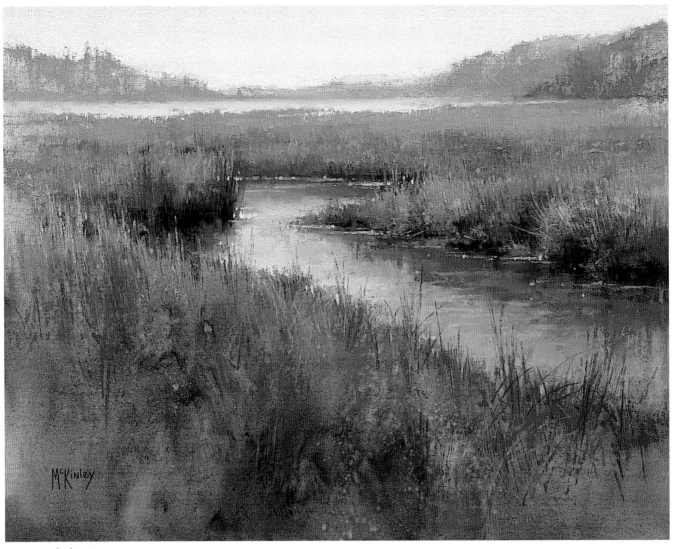

6 Finish the Painting

Before proceeding toward the finish, take a break. By resting from the concentration of the painting, you will come back to it with a fresh perspective. When you return to the painting, listen to it. Reevaluate your original concept so you can do what is needed to make the painting work, rather than force it to a predestined conclusion.

The final touches can be subtle. Strengthen the violet in the right-side grasses, which will intensify the green-silhouetted grasses in front of it and add interest. More separation of the water and shore can be accomplished with the addition of more light sparkles. Add intense, sharp notes of green to the green grasses on the left to make them stand out more. Paint soft violet-gray grasses in the foreground and silhouetted along the foreground shore, pulling the bank up above the water level. The violet helps to tie together

the violet from the back into the foreground, creating more harmony. It is the same value but weaker in chroma so as not to compete with the focal area. Add some subtle, delicate golden grasses to the right shoreline to counterbalance the center of interest area. A few more notes of green can be added to the foreground grasses and a final strengthening of the light drifts on the water behind the grasses in the center of interest.

Compare this studio piece to the field study on page 118. The experience and knowledge gained in the field study is translated to the studio piece and makes it stronger than working from a photo alone.

Fir Island Afternoon
14" × 18" (36cm × 46cm) by Richard McKinley

When is Your Painting Finished?

Overworking is probably the most common problem for beginning pastel artists. It's easy to think "just one more thing" will make your painting perfect, or that adding more and more detail will solve problems. Even if you've already heard the phrase "less is more" from an art instructor, how do you know when you have done enough? When should you quit?

The 75% rule

Consider the steps of a pastel painting as beginning with a sketch, a block-in or underpainting, and then an application of color over the entire surface. Working from big shapes to smaller shapes, and dividing those shapes into still smaller ones when necessary, bring your painting to a point that feels about 75 percent complete overall.

Then finish your focal point. Remember that one way you direct the viewer's eye to the focal point is by letting it be the area which has the most detail. Bring it into focus, just as much as you need to in order to make it clear what the subject is. Then step back and study your painting.

Analyze the whole

Looking objectively at the painting, ask yourself these questions:

- Is the focal point defined? Will the viewer know what it is and that it is the most important area of the painting?
- Are any other areas competing with the focal point? If so, could they be softened by muting edges (tapping with your finger or layering a soft pastel over a hard edge)?
- Are the values correct? Are the foreground values in higher contrast than distant values, and do the values progress back in space properly? If not, would an adjustment to values improve the painting? Are there any areas that could be improved by massing values together and removing small prominent shapes of either light or dark?
- Are the temperatures correct? Warm colors come forward and cool colors recede; are there any warm colors in the distance that need to be cooled, or cool colors in the foreground that need to be warmed?

- Is the drawing correct? If your subject is buildings, is the perspective right? If it's a figure, is the anatomy correct? If it's a landscape, are the elements correctly drawn? If you see a major drawing error at this point, a section may need to be brushed off and redone. (See page 52 for techniques of brushing off or removing pastel for reworking an area.)

Once you have answered these questions, make any corrections necessary. If possible, do so without reference to the photograph or sketch you worked from. Let the painting stand on its own and make the changes you've determined are necessary. Try to make only the corrections to the problems you've identified, and don't wander off into tweaking areas that don't need it.

Move out of the studio

After you've made the necessary corrections, take the painting out of your studio or workspace. Put it in an area where you will see it from a distance and unexpectedly. When you come into the room where it is, at the moment you see it, try to comprehend it as a whole, and see if any serious flaws jump out. If not, wait a day or two and look at it again. It can also be helpful to actually put it out of sight for a couple of days, and then set it where you can see it from some distance. If no flaws appear at this point, consider whether it may actually be done.

When you look at your painting at this stage to see if it is truly finished, don't let yourself "play around" with it. (Removing it from the studio and easy access to your pastels will make it harder to spontaneously start fiddling with the painting.) Before you make any change, ask yourself if the change you want to make will really make a difference. Will it improve the painting? If you're not sure, wait another day or so and look at it again.

It's often the case, when our paintings are near completion, that we artists are enjoying the subject and the process so much that we don't want to quit. But it's better to let go of a painting that's actually done and start another one than to overwork.

Sign your painting

When you're done with your painting, add your signature. Many artists struggle with this, but it can be quite simple. You may choose to sign your full name, or only your last

name. You can print it or write in cursive. It's usually best to put your signature in an unobtrusive area, visible but not competing with the painting for attention.

A nicely sharpened pastel pencil in a contrasting color is a good tool for signing your painting. You can also use an ordinary lead pencil if you have a space to sign your name where the contrast of values will let the lead pencil signature show up.

If the tooth of the paper is overly filled where you want to affix your signature, you can apply a little fixative. Shield the rest of the painting with a piece or two of paper, and apply just a light quick spray of fixative to the space where your signature will go.

Storing your painting

Pastel paintings must be framed under glass before they can be completely protected, but there are ways to store them temporarily until you can get them framed.

Glassine paper looks a little like shiny wax paper (don't use actual wax paper, though, as it will harm the pastel). You can buy it in rolls or single sheets, and it's quite inexpensive. Cover your painting with a sheet of glassine and tape it on the back. It's important that once you lay the glassine on the surface of the painting, it should not shift or rub, as that will blur your painting.

If you want, you can tape the painting to a piece of foam board or mat board and then cover it with glassine. This gives a sturdy backing to further protect the painting.

Tracing paper pads are adequate storage for small paintings for a short time. Some artists use clear plastic bags, but like tracing paper, they will lift off a little pastel.

Whichever method you choose for protecting your paintings, they should be stored flat, facing upwards, or standing vertically. Stacking paintings that are protected by glassine should not be a problem, but avoid anything rubbing or creating friction on the surface.

Keep your early work

If you keep a few of your early pastel paintings, they will provide inspiration to you in years to come. Take them out and look at them every year or so, and you'll see how far you've come. Remember that the only work you should compare

yours to is your own. Looking at your early work now and then will help you see how much you've learned and inspire you to do more.

Where do you go from here?

Pastel is an exciting and fun medium, and there are many ways to use it. Experimenting and trying new techniques will help you figure out what works best for you, and as you continue to work you'll develop your own preference and your unique style.

There are many resources available to the pastelist, including books and magazines on the subject. You may also want to consider taking an occasional workshop in pastel techniques from an artist whose work you like.

The most important thing is to keep painting. Learning to paint is a journey, and it can be an exciting one that will last the rest of your life. Congratulations on taking the first steps of the journey, and happy painting!

the pitfalls of overworking

Overworking a painting is a matter of adding unnecessary details or elements. Unless you are painting in a photorealistic style, no area should be tightly focused and detailed except the focal point.

Overworking can include adding too many busy, small shapes. Big shapes give the viewer's eye a resting point. Small shapes may be required in the focal point, or it may be that the focal point can be defined without them. Busy, small shapes all over the painting are not generally helpful.

Overworking can create muddy colors in pastel. You know you can layer light over dark, but if you then change your mind and apply a dark layer again, and then more light, and so on, you'll end up with muddy colors and neutral values. Layering warm and cool repeatedly can also create muddy colors. Keep the application of layers within the same value and temperature ranges in general, unless you're adding a final highlight.

Overworking can include creating too many focal points or points of interest. For a strong painting, you should have one clear focus, and everything else should be subordinate. Compare it to a room full of people. If one person speaks loudly and everyone else is silent, you hear the speaker. If everyone shouts at once, you don't hear anything clearly. Let your focal point speak clearly for the painting.

Contributors

Deborah Bays's favorite medium is pastel. Her work has been featured in *Southwest Art*, *Colorado Expression*, *The Artist's Magazine* and *The Pastel Journal*. She received a grand prize award in the 2004 Pastel 100, and the first place award for still life in the 22nd Annual Art Competition of *The Artist's Magazine*. Her work is also included in *Pure Color: The Best of Pastel*, edited by Maureen Bloomfield and James A. Markle (North Light Books, 2006). Bays is represented by galleries on both coasts as well as in Colorado, and Somerset House Publishing is currently offering selected Bays paintings reproduced as fine art prints.

Greg Biolchini, Pastel Society of America Master Pastelist, has been featured in nationally published books and magazines including *Pure Color: The Best of Pastel*, edited by Maureen Bloomfield and James A. Markle (North Light Books, 2006) and *The Pastel Journal*. His pastel paintings are in corporate, university and museum collections and have received honors and awards in many national shows. Biolchini teaches painting workshops for art groups nationwide. View more of his work at www.biolchini.com.

Thomas DeCleene graduated with a bachelor's degree in fine art from the University of Wisconsin–Milwaukee after spending four years in the U.S. Air Force as an illustrator. Thirty-plus years were spent in graphic arts, primarily as a color artist, before he was able to pursue fine art on a full-

Near Dawson
12" × 18" (30cm × 46cm) by Tom DeCleene

time basis. In recent years he has found success in both regional and national competitions, received numerous awards and been published in both *The Pastel Journal* and *The Artist's Magazine*.

Sam Goodsell has been painting seriously since childhood. He attended the High School of Art and Design in Manhattan, New York, followed by years at the Art Students League in New York. His work drew national attention when he won Best of Show in the Pastel 100 competition with a lengthy feature published in March 2003. Since then he has continued to exhibit his work and win awards and teaches an occasional workshop along with regular classes at the Pastel Society of America facility in New York City.

Bill Hosner earned his BFA at Wayne State University and studied illustration at the Center for the Creative Studies, College of Art and Design. For seventeen years he worked as an illustrator, achieved national recognition and was honored with many accolades and awards in advertising art. At the peak of a successful career, he left the commercial art world to focus on fine art. He studied with Harley Brown and Dan Gerhartz and developed a keen interest in plein air painting and painting figures from life. Since then his work has received national recognition, winning numerous awards in exhibitions and being selected for inclusion in publications. View more of his work at www.WilliamHosnerFineArt.com.

Richard McKinley has been a professional working artist for thirty-five years and has more than thirty years of teaching experience. He is a Signature Member of the Pastel Society of America and the Northwest Pastel Society; a Signature Distinguished Pastelist with the Pastel Society of the West Coast; Signature Master Pastelist, Pastel Society of Oregon; and a member of the Oil Painters of America. He writes frequently for *The Pastel Journal*, and his work has been included in *A Painter's Guide to Design and Composition* (North Light Books, 2006), by Margot Schulzke, and *Pure Color: The Best of Pastel*, edited by Maureen Bloomfield and James A. Markle (North Light Books, 2006). View more of his work at www. mckinleystudio.com.

Eye of Dawn
11.5" × 17.5" (29cm × 44cm) by Ruth Summer

Desmond O'Hagan is a Master Pastelist with the Pastel Society of America. In 2005, he was inducted into the first "Masters Circle" of the International Association of Pastel Societies. His work has been featured in magazines including *The Artist's Magazine*, *The Pastel Journal*, *International Artist*, United Airlines' *Hemispheres* magazine, and *Gekkan Bijyutsu* (Japan). O'Hagan's art is in public and private collections in the United States, Japan, Canada and Europe. View more of his work at www.desmondohagan.com

Deborah Christensen Secor has always focused on drawing and painting, but in 1986 she began using pastels exclusively. This led to significant developments in her professional life, from success in galleries to teaching pastel painting, from the inception of The Pastel Society of New Mexico to writing for *The Pastel Journal*. Her work is featured in *Pure Color: The Best of Pastel*, edited by Maureen Bloomfield and James A. Markle (North Light Books, 2006). She continues to paint, teach and write about art, always finding new artistic challenges. View more of her work at www.DeborahChristensen.com.

Ruth Summer has been painting for many years and working mostly in pastel for the last ten years. She was the associate editor of *The Pastel Journal* from 1999–2002 and wrote extensively for the magazine for several years. She is currently traveling and painting in Europe.

index

look for these other fine north light books!

Are you itching to expand your creativity into new mediums? Here is your essential guide to techniques for all the major painting mediums (acrylic, colored pencil, oil, pastel and watercolor). This informative and inspiring book covers materials, color, value, composition, and step-by-step painting techniques and demonstrations, all clearly and beautifully illustrated. It's everything you need to begin, develop and perfect your craft.

ISBN-13: 978-1-58180-870-4
ISBN-10: 1-58180-870-4
Paperback with flaps, 224 pages, #Z0228

Pure Color is pure inspiration for all artists. From luminous landscapes to moody still lifes, this stunning collection showcases more than 125 glowing works from over 90 of today's most accomplished pastel artists. Every oversized page features big, beautiful artwork spanning a diverse range of styles and subjects. You'll also find insightful commentary from all the artists detailing their creative processes and artistic techniques, so you can use the same principles in your own work. Whether you're an artist or an art lover, Pure Color: The Best of Pastel will inspire you to let your imagination soar!

ISBN-13: 978-1-58180-764-6
ISBN-10: 1-58180-764-3
Hardcover, 144 pages, #33433

The overwhelming beauty of the outdoors is one of the most inspiring—and elusive—subjects for painters. With Landscape Painting Inside & Out, Kevin D. Macpherson shows you how to see like an artist and how to recreate your vision into stunning outdoor scenes. Take your art to the next level with Macpherson's insightful process and inspiring commentary about the painting life.

ISBN-13: 978-1-58180-755-4
ISBN-10: 1-58180-755-4
Hardcover, 144 pages, #33422

These books and other fine North Light titles
are available at your local fine art retailer
or bookstore or from online suppliers.